ART AND HISTORY OF THE
KREMLIN
OF MOSCOW

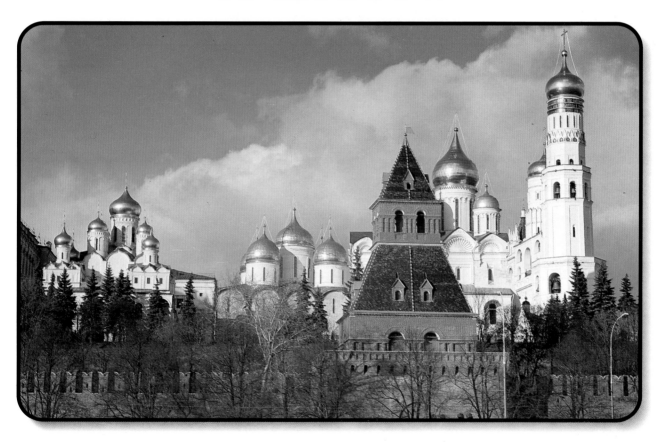

155 photos in colour

P9-BBT-530

BONECHI
WB

CONTENTS

© Copyright by WELCOME BOOKS
3-ja Tverskaja-Jamskaja 30 —4 –30
125047 Moskva, Rossija
Tel./Fax 095 2509342

© Copyright by Casa Editrice Bonechi - Via Cairoli 18,b - 50131 Florence - Italy
Tel. 055 576841 - Fax 055 5000766 - E-mail: bonechi@bonechi.it - Internet: www.bonechi.it

Publication created and designed by: Casa Editrice Bonechi
Text by: Nonna Vladimirskaya and Rimma Kostikova
Designed by: Alexander Voyeikov
Translated by: Mikhail Nikolsky
Photographs by:
Valentin Chertok, Yevgeni Gavrilov, Daniil and Yevgeni Gherman, Yuri and Oleg Grigorov, Viktor Polyakov,
Viktor Solomatin, Alexander Zakharchenko,
and also from the photograph collections of Welcome Books and Bonechi Publishing House.

Printed in Italy by
Centro Stampa Editoriale Bonechi

ISBN 88-8029-429-6

* * *

INTRODUCTION

And every stone on every tower
Is sacred lore from age to age passed on.

Mikhail Lermontov

The architectural ensemble of the Moscow Kremlin, incorporating the efforts of many generations, is an organic blend of the present and the hoary past, history and modern times...

The Moscow Kremlin stands on the left bank of the Moskva River at the point where the Neglinnaya River joins it. Geographically, it is a high ridge dividing the drainage areas of the two rivers, and part of the plateau on which Red Square and Kitaigorod are situated. Its riverside sloping edge forms a single whole with the lowland part of Kitaigorod known as Zaryadye.

The area covered by the Kremlin within the fortress walls is 27.5 hectares. The ridge on which it stands, Borovitsky Hill, or "Kremlin Riverside Hill," as it was called in olden times, is about 25 meters high. Apparently, it was named after Bor (meaning "pine forest") or Borovichi, the promontory which it occupied. Thus, in a description accompanying an old drawing of the Kremlin, its Borovitskiye Gates are called the "High Forest Gates".

Seen from above, the Kremlin looks somewhat like an irregular triangle in shape, its walls spanning a total of 2,235 meters. It stretches for about 676 meters west to east and for 639 meters northwest to southeast. It was early in the 16th century, when the construction of its fortifications was completed and the Alevizov (Alevisio's) Moat was dug along the wall on its Red Square side, that the Kremlin finally became distinct from the rest of the city center.

The old Kremlin settlement, which emerged as a center of crafts and trade, rose to a prominent position thanks to its exceptionally convenient geographical location, that of a junction of water and overland routes that crossed at the foot of the hill. Its advantageous location ensured the safety of the citadel. In ancient times, this wooded land was inhabited by the Slavic tribe of Vyatichi, who were pagans, and Moscow became one of the centers of Christianization of this land.

The early period of the history of Moscow is inseparable from that of the Kremlin. Both of them are considered to be founded in 1147, the year when Moscow was first mentioned in the chronicles: that year, Prince Yuri Dolgoruky (Long-Armed), the son of Prince Vladimir Monomakh of Kiev, invited his ally, Prince Svyatoslav Olgovich of Chernigov-Seversky, to Moscow for a feast on his way back home after a successful military campaign.

And yet, as historian and archaeologist Ivan Zabelin (1820-1908/9), an outstanding authority on the history of the Slavs, correctly believed, "the Moscow or, more precisely, the Kremlin settlement came into being much earlier than a tribe led by Prince Ryurik's descendants appeared in these parts". The scholar's hypothesis has been corroborated by the archeological surveys of Borovitsky Hill. The oldest finds that have been uncovered here include a stone battle-ax-cum-hammer dating from the late 3rd to mid-2nd millennium B.C.

The first record in the chronicles of a wooden fort built on the site of the Kremlin dates back to the year 1156. The remains of the walls erected at the time are one of the most valuable archaeological finds.

The wooden structures built inside the Kremlin often fell victim to devastating fires, enemy raids and natural disasters. In the first third of the 13th century, one of the blackest periods in the history of Russia, when great nomadic Mongol-Tatar hordes swooped on her, putting every living being on their way to fire and sword, the Kremlin was razed to the ground. For nearly two and a half centuries afterwards, the yoke of the Golden Horde was draining the spirit of the Russian people, who heroically withstood the innumerable armies, checking their advance further into the heart of Europe. A reminder of the bitter trials that befell the Kremlin are the treasure-troves, hidden underground nearly eight centuries ago, that have recently been found by archaeologists. Today these fine specimens of Old Russian art are among the most valuable possessions of the Russian cultural heritage.

In the 14th century, Moscow entered the arena of world history. The city began to grow bigger and richer. In 1339, Prince Ivan Danilovich of Moscow, who was nicknamed Kalita ("Moneybag") by his contemporaries and who has gone down in history as "the gatherer of the Russian lands", built new walls of oak around the Kremlin, which thus became a formidable medieval fortress. This is eloquently attested by his contemporaries' rapturous comments, a number of which have survived to this day. It was during that period of its history that the word "Kremlin" or "Kremnik," meaning "citadel" or "stronghold", appeared for the first time in the Russian chronicles. The first mention of the "city of Kremlin" was made in the Voskresenskaya Chronicle in 1331.

It is also known that, unlike the chroniclers of the earlier period, the memoir writers of the late 15th-early 17th centuries did not know the word "Kremlin" and used such terms as "Castle," "Fortress" and, from the late 16th century, "Old Town" instead. It was only in the second half of the 17th century that the word "Kremlin" began to appear in memoirs.

In the 14th century, Moscow began to play a leading role in the process of unifying the isolated Russian principalities in a single centralized state. Written sources dating from that period ever more often mention the erecting of stone structures in the Moscow Kremlin. Thus, between the 1360s and 1420s, fifteen stone buildings were erected by Moscow architects. Stone construction began in the Kremlin long before the arrival of Italian architects in Moscow and was only briefly interrupted during periods of internecine strife and natural disasters. The growing importance of the Kremlin influenced the shaping of its architectural tradition: it is here that the origins of the formation of the Kremlin architectural ensemble are to be found. At the time, the foundations

of the Kremlin as the seat of government of the Russian state began to be established. It was now reliably protected by whitestone walls and towers built by Grand Duke Dmitry Donskoi of Moscow in 1367-1368.

These were the first stone fortifications to be built in the period of Vladimir-Suzdal Rus that marked a new stage in the development of the Moscow school of architecture. On two occasions, in 1368 and 1370, the mighty fortress was besieged by the troops of Grand Duke Olgerd of Lithuania and each time the siege proved fruitless. The whitestone Kremlin citadel ensured the protection of the city, which made it possible for the Russian troops with the Moscow army at the head to mount a major campaign against the Golden Horde and win a brilliant victory in the Battle at Kulikovo Field in 1380. Thus Russia was delivered from national humiliation.

During the restoration of the present Kremlin walls and towers in 1945-50 and later, whitestone blocks originally cut and dressed by stonecutters and then reused in rebuilding the fortifications were found, but it was impossible to study the structural features of ancient masonry. It is known that the whitestone citadel had six gate towers: the Frolovskaya (St. Florus'), Timofeyevskaya (St. Timothy's), Nikolskaya (St. Nicholas'), Cheshkova or Vodovzvodnaya (Water), Borovitskaya, and Rizpolozhenskaya (Deposition of the Virgin's Robe), now known as the Troitskaya (Trinity), Towers. Rising at the wall corners were round blind towers: the Sviblova and Beklemishevskaya Towers on the side of the Moskva River and the Uglovaya (Corner) Tower standing on the steep bank of the Neglinnaya River, which has been piped underground (today the Middle Arsenal Tower stands on this spot). All the gates and towers, except the Nikolskaya Tower, stood on almost the same spots where the newer ones bearing the same names stand today. The whitestone walls stretched for a total of two kilometers.

Rising high near the gilt-roofed palace of Grand Duke Dmitry Donskoi was the Church of the Savior on the Bor, built by Ivan Kalita in 1332. It was also in the 14th century that the first cloisters — the Monastery of the Archangel Michael's Miracle at Chonae, founded in 1358, and the Convent of the Annunciation, instituted in 1386 — began to be built in the Kremlin. In 1365, the stone Cathedral of the Archangel Michael's Miracle at Chonae was erected.

The type of a small single-domed cruciform church decorated with kokoshniki (a series of corbeled-out, round or pointed arches arranged in receding tiers for the purpose of supporting the elements of the superstructure.—Tr.) and carved friezes on the façades, which had developed from the Vladimir style, formed the basis for the subsequent development of Moscow architecture, although the first samples of early Moscow stone architecture were not a direct continuation of the Vladimir-Suzdalian architectural tradition. The above-ground parts of the structures of that period have not survived, but the surveying of their crypts and the studying of archaeological finds and written monuments discovered in them are of great interest.

The first Moscow churches were painted and decorated by the finest Russian and Greek masters, including the famous icon-painter Theophanes the Greek. In the late 14th-early 15th centuries, iconostases (an iconostasis is a partition or screen, decorated with icons, that separates the sanctuary from the rest of the church.—Tr.), which are a purely Russian form of decorating the church interior, began to appear in the Kremlin churches. The late 14th and the first third of the 15th century was the period when the great Russian artist Andrei Rublev, who made an invaluable contribution to the development of Old Russian art and who, in particular, painted a number of icons for the iconostasis of the Kremlin Cathedral of the Annunciation, lived and worked.

The late 14th and early 15th centuries were a major historical stage in the development of Russian national art and culture. It was during that period that the various local architectural schools merged to form a single national school of architecture.

Ivan III, the grand duke of Moscow (1462-1505), who adopted the title of Sovereign of All Russia, completed the unification of Russian principalities into a single centralized state, which had been started by his predecessor Ivan Kalita. There were two distinct historical periods in his reign: between 1462 and 1480 he succeeded in annexing the vast Novgorodian territories, the Rostov Principality and the Dmitrov Appanage to Moscow and from 1481 to 1505 the unification of the Russian lands under the principality of Moscow was completed. The shaping of Russian national statehood and the growth of Russia's international prestige led to the formulation of an official ideology that viewed the Russian state as the legitimate successor of the two greatest world empires, the Roman Empire and the Byzantine Empire, and Moscow was described as the "Third Rome". Now, a hundred years after the Battle at Kulikovo Field, the Tatar yoke was finally thrown off, which created economic and political prerequisites for carrying out extensive construction work in the Kremlin, the seat of the Moscow grand dukes.

It was decided to build the new Kremlin walls, without pulling down the old ones, on a much larger perimeter, which resulted in a substantial increase in the area covered by the fortress. The reconstruction plans provided also for setting up a new, improved system of fortifications and for making use of a highly sophisticated water development system that made it possible to divert the waters of the Neglinnaya River from the Kremlin and, at the same time, to create a reliable water obstacle for protection against enemy invasions. As a result, the new Kremlin became a model sample of the fortification art of the day.

In the 17th century, however, the Kremlin fortifications lost their significance as defenses. At the time, there arose a pressing need for imposing buildings that would promote the idea of the grandeur of the sovereign's power. In the new conditions, the Kremlin turned into a magnificent residence of the country's ruler and the church hierarchy.

The general upsurge of the people's national feeling and the successes of Moscow's foreign and home policy manifested themselves in 16th and 17th century Russian painting. All varieties of applied art also made great progress in Moscow at the time.

One of the principal Kremlin attractions which is now a world-famous museum, the Armory, first mentioned in the Concise Chronicle in 1537, became a depository

of precious articles, which is confirmed by the testaments of Ivan IV the Terrible and other representatives of the royal dynasties. Initially, the countless riches of the Russian state treasury were kept in a stone building, the so-called "Treasury Court", specially built for the purpose in 1484-1485 between the Cathedral of the Archangel Michael and the Cathedral of the Annunciation.

The first efforts to set up a museum for preserving and exhibiting the treasures of the Russian grand dukes and czars, in particular, those mentioned in Ivan Kalita's last will and testament of 1339, were made by Peter the Great back in 1718.

Today Moscow's ancient historical nucleus, the Kremlin, is the site of a museum complex of national and worldwide significance, the Moscow Kremlin State Historical and Cultural Reserve, featuring unique monuments of 14th to 19th century architecture such as the Cathedrals of the Dormition, the Archangel Michael and the Annunciation, the Church of the Deposition of the Virgin's Robe, the Patriarch's Palace with the Church of the Twelve Apostles, and the Ivan the Great Bell Tower with a campanile and Filaret's Annex.

These monuments and fortifications of the Kremlin embody the historical mission of Moscow as the center of the formation of a single Russian state and it is precisely for this reason that they have for centuries been regarded as an epitome of the Motherland, as a symbol of Russian statehood.

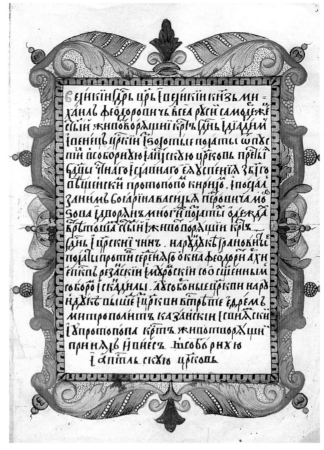

Cathedral Square of the Moscow Kremlin. Miniature and text from the book "Election to the Throne". 1672-1673.

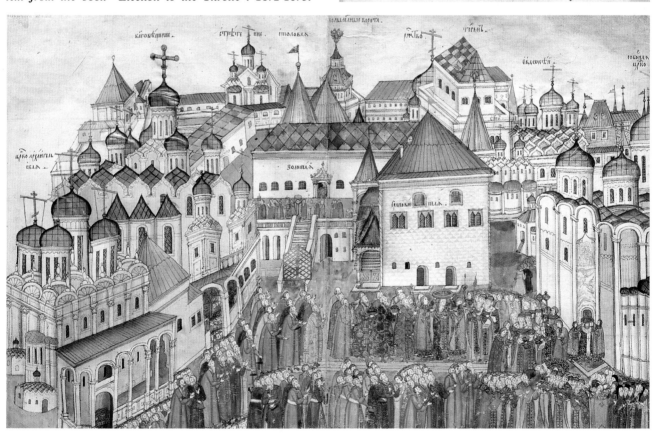

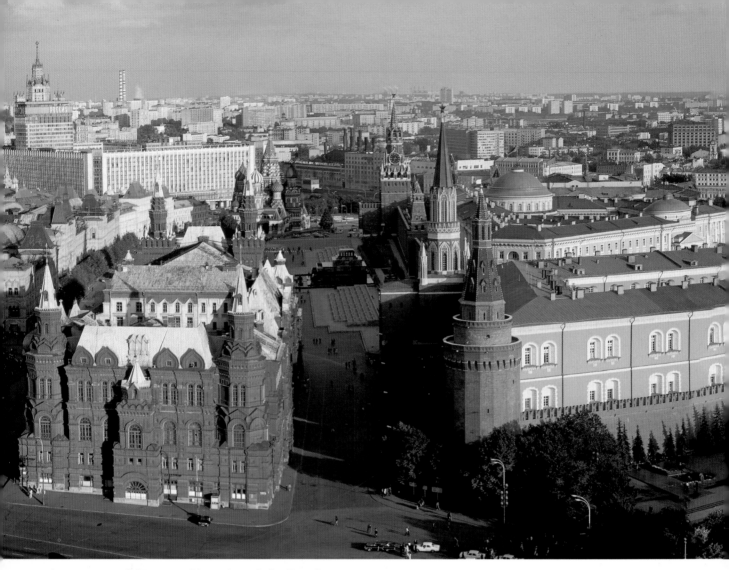

A panorama of Moscow with a view of the Kremlin.

THE KREMLIN WALLS AND TOWERS

The Kremlin has long been dubbed a stone fairy tale. And this fairy tale has been made up by many generations and in the course of many centuries. Despite numerous subsequent changes, additions, and alterations of its towers, the 15th-century layout of the Kremlin has, in the main, survived.

Seen from above, the Kremlin fortress, built of red brick, has the traditional shape of an irregular triangle with the walls spanning a total of 2,235 meters. On each side there are seven towers, counting the corner ones. In all, there are 19 towers in the Kremlin walls plus a small turret built right on top of the wall and still another one, the Kutafya Tower that used to be a bridgehead watchtower, standing separately at the entrance to the Troitsky Bridge under which the Neglinnaya River used to flow.

The three corner towers are round in shape. Standing between them on the perimeter of the walls are rectangular towers, some of them having gateways.

The walls, topped with bifurcated merlons, are from 5 to 19 meters high. The height of the towers, including the hipped roofs added in the 17th century and the stars on top of them, ranges from 28 to 71 meters. At one time, wooden tents with lookouts were put up on top of the towers and on some of them tocsins and hour bells were hung. In olden times, the walls were covered with ridged wooden roofing. The purpose of these new fortifications was determined by the special

role played by the Kremlin in the defense of the Russian state.

The Kremlin walls and towers were erected by Russian master builders. Supervising the construction work were Italian engineers and architects, whose names have been preserved by the grateful posterity.

They were Marco Fryazin (Marco Ruffo), Pietro Antonio Solari, a hereditary architect who had taken part in the construction of the Milan Cathedral, and Antonio and Alevisio Fryazin.

Interesting records of the Italians' work in the Kremlin have survived. Thus, the travel notes of Venetian ambassador Ambrosio Contarini dating from 1476 contain information about "master Aristotle from Bologna" (meaning Aristotle Fioravanti), who "built a church in the square", and also about the topography of the Kremlin "castle".

In the second half of the 15th century, Vassily Dmitriyevich Yermolin, the outstanding Russian architect and sculptor, worked in the Kremlin. He restored the dilapidated section of the whitestone wall of Dmitry Donskoi's Kremlin "from the Sviblova Bartizan to the Borovitskiye Gates in stone". In connection with the restoration of the Frolovskaya (Spasskaya) Tower, he created two whitestone sculptures. One of them, St. George the Victorious, which is the emblem of Moscow, was put up on the outer side of the gates in 1464. This monument has survived, but it has lived through

numerous alterations and suffered serious damage over the centuries and is now being restored.

To strengthen the Kremlin defenses on its eastern side where the *posad* (artisans' and merchants' settlement) was situated, a wide and deep moat filled with water was built along the Kremlin wall to the design of Alevisio Fryazin in 1508-1516, during the reign of Grand Duke Vassily III. Wooden drawbridges leading to the Spasskiye and Nikolskiye Gates of the Kremlin were thrown across the moat; later on, in the 17th century, they were replaced with stone bridges that became centers of brisk trade.

Despite certain details making the Kremlin look not unlike a regular medieval castle, it has preserved a spatial layout characteristic of the center of an Old Russian town.

Century after century the system of defenses of the Kremlin citadel was constantly improved. As the development of artillery progressed, the architecture of the Kremlin fortifications changed.

Artillery was one of the greatest inventions of the Middle Ages. Heavy cannon shooting iron balls became the principal means of destroying fortress walls and almost completely replaced ancient projectile weapons. The distance between the towers was determined by the effective range of the cannon used in their defense. On the most vulnerable southern side of the Kremlin fortress the towers stand particularly close to each other.

In the 17th century, cannon stood on the walls and inside the towers of the Kremlin, in the basements were powder magazines where gunpowder and small arms were kept, and the gate towers were guarded by *streltsy* (royal guards).

According to the Russian chroniclers, in the 1620s construction work in the Kremlin was resumed on a grand scale. In the period between 1625 and 1685, tiled hipped roofs were added on top of all the Kremlin towers, except the Nikolskaya Tower. The hipped roofs lent the austere Kremlin fortress a picturesque appearance, increasing the aspiration of its towers to rise still higher. According to Ivan Zabelin, "the addition of the tops did not make the Kremlin defenses any stronger, but this lent it a different everlasting strength by making it an artistic epitome of the poetry and spirit of pre-Petrine Russia". The Kremlin began to gradually lose its significance as a citadel.

In the early 18th century, however, in view of the Russo-Swedish war, known as the Northern War, that was being waged at the time, the Kremlin was fortified with bastions and moats on the orders of Peter the Great, and embrasures for cannon were made in the towers.

Moscow and the Kremlin suffered greatly in the 1812 war with France. After the war, however, everything was restored. The restoration work was carried on from 1817 to 1822 under the supervision of the architect Osip Beauvais. It was then that the old Alevizov (Alevisio's) Moat running along the Kremlin wall on its side facing Red Square was filled up.

In 1937, glowing stars of ruby glass were mounted on the five tallest towers. Their framework is made of stainless steel and covered with gilded red copper. To ensure their even glow, unique 3,700 to 5,000 watt incandescent lamps were manufactured.

Beginning with the 1970s, large-scale restoration work was launched in the Kremlin.

Tainitskaya Tower

The erection of the Tainitskaya Tower (Tower of Secrets) in 1485 marked the beginning of the construction of the new Kremlin, an ensemble of fortification structures built on an exceptionally grand scale having no precedent in Russia. The tower, built under the supervision of the Italian architect Antonio Fryazin, replaced the old Cheshkovy Gates of the Kremlin dating from the days of Grand Duke Dmitry Donskoi.

The name of the tower is derived from two secrets: a secret well hidden inside it and a secret underground passage to the Moskva River that supplied the Moscovites with water in case of a siege. The Tainitskaya Tower with entrance gates had a bartizan connected to it by a stone bridge. Inside the tower there was an immense room covered with great vaults.

In 1812, when Napoleon's troops were retreating from Moscow, the tower was damaged by a blowup, but it was soon restored. The Tainitskaya Tower is 38.4 meters high.

Vodovzvodnaya Tower

In 1488, another round tower, the Sviblova Tower, named after Boyar Sviblov, was built at the southwestern end of the Kremlin. The tower had a well and a secret passage to the river.

In 1633, a water elevating machine that supplied the entire Kremlin with water was installed in this tower. According to its contemporaries, this machine, built under the supervision of Englishman Christopher Halloway, cost several kegs of gold. It was then that the tower was given its present name, meaning Water Tower. In 1672-1686, a tiered hipped top was added to the tower. In 1812, during the retreat of Napoleon's troops, the tower was blown up, but in 1817-1819 it was restored under the supervision of the architect Osip Beauvais. The massive lower cylinder of the tower is finished in the rustic style, topped with decorative machicolations and provided with large windows. A star of ruby glass crowns the tower. The tower is 57.7 meters high (61.25 meters with the star).

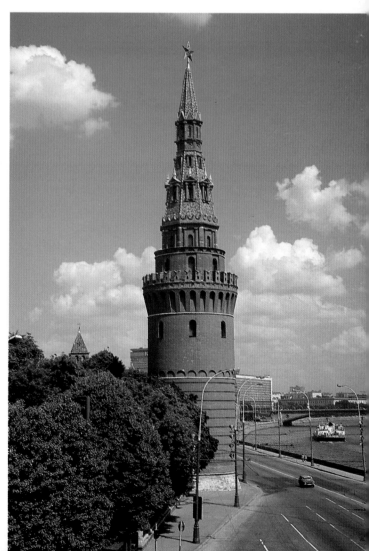

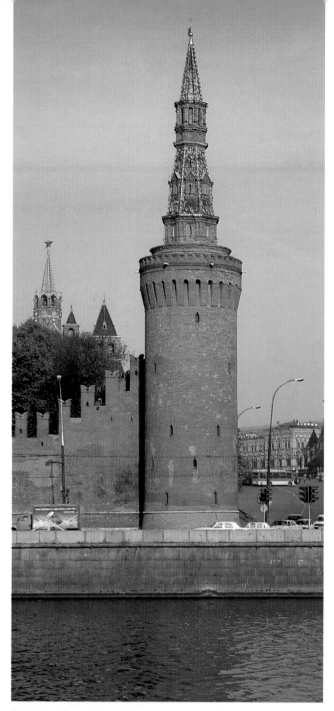

Beklemishevskaya Tower

In 1487, the Italian architect Marco Fryazin (Marco Ruffo) built the tall round Beklemishevskaya Tower at the southeastern corner of the Kremlin. It was named after Boyar Beklemishev, whose manor was located in the vicinity in the 15th century. In the 17th century it was topped with a beautiful tall hipped superstructure that softened its grim appearance and gave it elegance and stateliness. In the early 18th century, during the Northern War, bastions were built around the tower and its embrasures were widened. This is one of the few Kremlin towers that have not been seriously altered over the centuries. Its height is 46.2 meters.

Konstantino-Yeleninskaya Tower

This gate tower was built in 1490 on the spot where a tower of the whitestone Kremlin dating from the reign of Grand Duke Dmitry Donskoi used to stand. The tower was named Konstantino-Yeleninskaya (Sts. Constantine's and Helen's) in the 17th century after the Church of Sts. Constantine and Helen that stood nearby. In 1680, an elegant hipped top on an arched rectangular base was built on top of the tower. Its gate was sealed. The *Razboiny Prikaz* (Criminal Office) was housed inside the tower, which was turned into a prison and popularly dubbed the *Pytoshnaya* (Torture) Tower. Its height is 36.8 meters.

Tsarskaya Tower

Next to the Spasskaya Tower is the Tsarskaya (Czar's) Tower, a small turret placed on the wall. Built in 1680, it has not been altered to this day. From here, according to legend, the czar would watch the important events taking place on Red Square. The shape of the tower is reminiscent of a small *terem* (Old Russian tower chamber). Its four pitcherlike pillars support an elegant octagonal tent roof topped with a gilt weather vane. The height of the tower, including the weather vane, is 16.7 meters.

Nabatnaya Tower

On the slope of the hill, known as the Vassilyevsky Slope, opposite the Cathedral of St. Vassily the Blessed, rises the Nabatnaya (Tocsin) Tower. It was built in 1495. The tower takes its name from the tocsin that once hung under its tent roof. At the sign of enemy detachments approaching the capital by way of Serpukhov or Kolomna Roads the watch would sound the tocsin, which could be heard all over Moscow. In 1771, during a popular unrest in Moscow known as the plague rebellion, the insurgent citizens sounded the tocsin calling the people to the Kremlin. After the rebellion was put down Empress Catherine the Great ordered the tongue to be removed from the bell. In 1803 the tocsin was taken down and is now kept in the Armory. The tower is 38 meters high.

Spasskaya Tower

The year 1991 saw the 500th anniversary of the Spasskaya Tower, a graceful ten-storied gate tower that has long

Part of the Kremlin wall. Left to right: the Konstantino-Yeleninskaya, Nabatnaya, Tsarskaya and Spasskaya Towers.

The Spasskaya Tower.

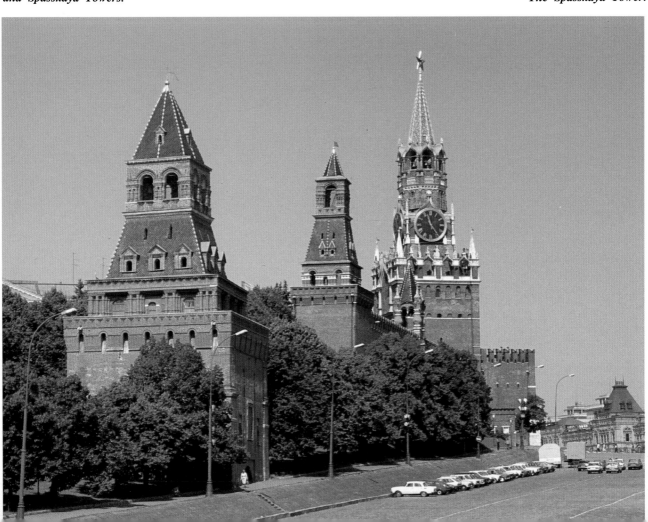

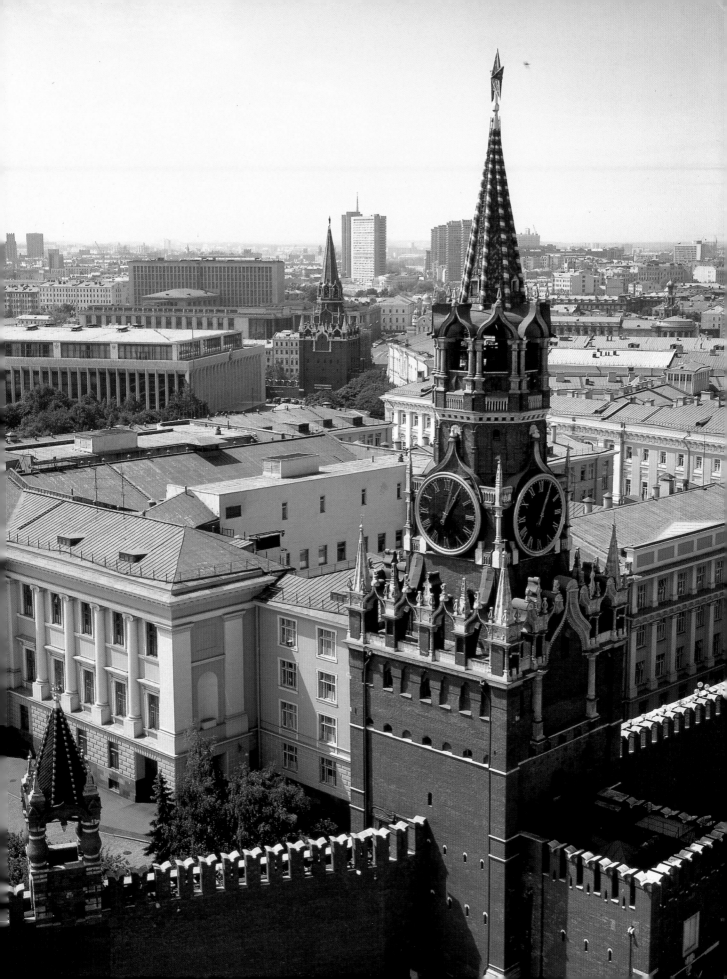

become one of the world-known symbols of the Kremlin. It is the most exquisite in decor and, perhaps, the most perfect in proportions among the Kremlin towers. It came into being as a result of adding a superstructure on top of the old Frolovskaya (St. Florus') Bartizan and was originally named the Frolovskaya Tower. In the 16th-17th centuries, its gates served as the royal entrance into the Kremlin. Ceremonial processions led by the Patriarch of All Russia passed through these gates and foreign ambassadors were met here.

In the 1650s, a double-headed eagle, the emblem of the Russian Empire, was mounted on top of the hipped roof of this main tower of the Kremlin. In April 1658, a royal *ukase* on renaming the Kremlin towers was promulgated. The Frolovskaya Tower was then renamed the Spasskaya (Savior's) Tower in honor of the Smolensk Icon of the Savior placed above the gateway on the side of Red Square, and also in honor of the Image of the Savior Not Made with Hands that crowned the gateway on the Kremlin side of the tower.

Tower clocks have been a special attraction of the Kremlin from time immemorial. They were installed here, for the first time in Russia, back in 1404. In the 17th century, as is known from contemporary sources, three Kremlin towers — the Spasskaya, Troitskaya and Nikolskaya Towers — had clocks in them. In 1624-1625, Russian master builders directed by Bazhen Ogurtsov built the octagonal multitiered stone turret which now surmounts the rectangular part of the Spasskaya Tower and Christopher Halloway, invited to work at the court of Czar Mikhail Feodorovich, mounted a clock on the tower.

Russian smiths and clockmakers Zhdan, his son Shumila and grandson Alexei Shumilov were assigned to implement this unique project. Mentions of the clock, whose design excited the contemporaries' imagination, are to be found in the travel notes of a number of foreigners who visited Muscovy in the 17th century. Thus, Baron Meyerberg, the ambassador of Emperor Leopold of Austria, writes: "On the Frolova Tower ... next to the palace bridge there is a clock. It indicates time from sunrise to sunset... It is the most splendid clock in Moscow". It was most likely after the great fire in 1701 that Peter the Great ordered the "old-fashioned" clock replaced by a new one with a carillon playing music. Time did not spare it either... The clock we see now — the famous Kremlin Chimes — was mounted on the Spasskaya Tower in 1851-1852 by the brothers Butenop. The clock mechanism with the chimes weighs a total of some 25 tons.

The melodious chiming of the clock's nine "quarter bells" sounds every quarter of an hour and it rings on the hour with its big bell weighing 2,160 kilograms. The clock is wound twice a day and it indicates Moscow Time, which is used as the basis for standard time throughout Russia.

The tower is 67.3 meters high (71 meters with the ruby star).

Nikolskaya Tower

In 1491, simultaneously with the Spasskaya Tower, Pietro Antonio Solari built another gate tower, the Nikolskaya (St. Nicholas') Tower, on the northern side

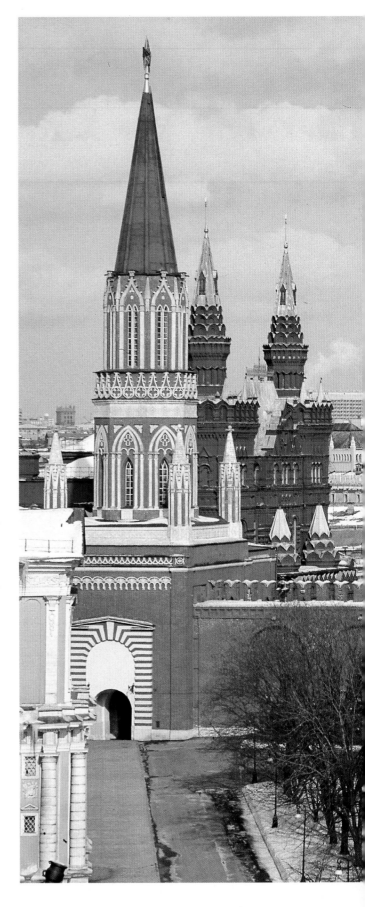

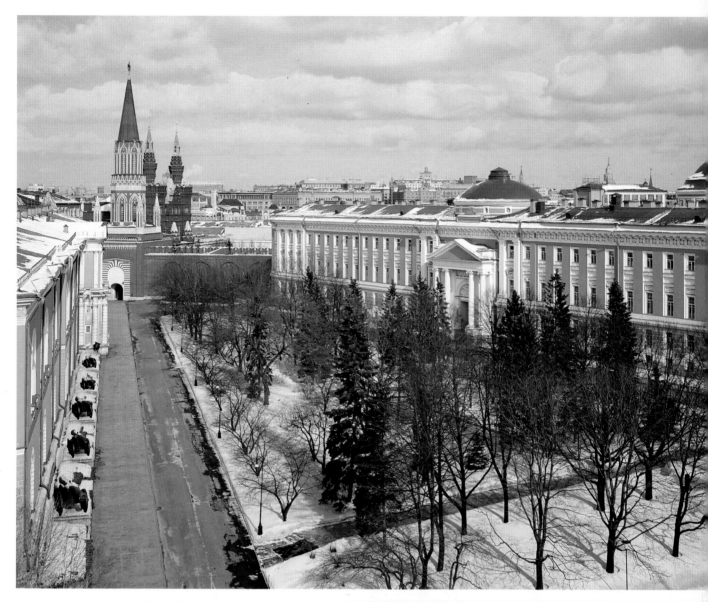

The Nikolskaya Tower and a detail of whitestone carving.

of the Kremlin. It takes its name from the icon of St. Nicholas that was mounted on the bartizan above the gates.

There is documentary evidence that this tower also had a clock. In 1780, a superstructure topped with a low hipped roof was built on the tower. In 1806, architect I. L. Ruska built an octagonal turret decorated with whitestone lacework elements and crowned with a tall spire in the Gothic style on top of the tower.

In 1812, during the invasion of Napoleon's troops, the upper part of the tower was destroyed. During the restoration of the tower in 1816-1819, four whitestone turrets were added on its corners. The tower, crowned with a ruby star, is 67.1 meters high (70.4 meters with the star).

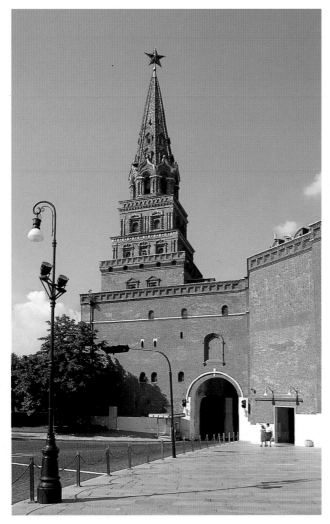

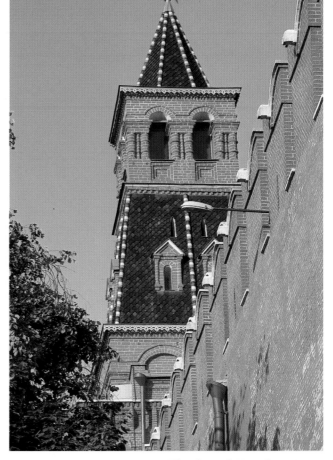

The Borovitskaya Tower.

The Second Nameless Tower.

Borovitskaya Tower

In the 1490s, Pietro Antonio Solari supervised the construction work of the Kremlin fortress.

On the western side of the Kremlin at the spot where the oldest exit from the Kremlin used to be, a gate tower named the Borovitskaya Tower was laid down in 1490. From its gates there was an easy slope leading to the Neglinnaya River. The Borovitskaya Tower was used, in the main, as a service building for the needs of the Royal Barnyard and Stable Yard that were situated next to it. The name of the tower reminds us of the dense *bor* (pine forest) that once covered Kremlin (or Borovitsky) Hill.

In the 17th century, three progressively smaller square tiers were built on top of the massive rectangular lower part of the tower and it was topped with an openwork octagonal section and a tall cone-shaped spire. In 1658 it was renamed the Predtechenskaya (St. John the Forerunner's) Tower after a church of the same name that stood in the vicinity, but the new name did not take root.

During the war of 1812, the Borovitskaya Tower was badly damaged by the neighboring Vodovzvodnaya Tower, which fell on it after the blowup. In 1816-1819, however, it was restored.

On top of the tower there is a star of ruby glass mounted on it in 1937. The height of the tower is 50.7 meters (54.05 meters with the star).

Pervaya Bezymiannaya Tower

In the 1480s, the Pervaya Bezymiannaya (First Nameless) Tower was built next to the Tainitskaya Tower. In the 15th and 16th centuries it was used for storing gunpowder. In 1547, the tower was destroyed by a fire and in the 17th century it was built anew and this time it was decorated with a hipped superstructure. In 1812, during Napoleon's invasion, the tower was blown up. It was only in 1816-1835 that it was restored under the supervision of Osip Beauvais.

The tower is 34.15 meters high.

Vtoraya Bezymiannaya Tower

The Vtoraya Bezymiannaya (Second Nameless) Tower stands to the east of the First Nameless Tower. In 1680, a square superstructure topped with an octagonal cone-shaped cupola with a weather vane was added to it. In olden times the tower had gates. In 1771, during the construction of the Grand Kremlin Palace, it was pulled down and then built anew. The tower is 30.2 meters high.

Blagoveshchenskaya Tower

To the east of the Vodovzvodnaya Tower there are seven towers on the Kremlin side facing the Moskva River.
One of them, situated between the Tainitskaya and Vodovzvodnaya Towers, is the Blagoveshchenskaya (Annunciation) Tower, built in 1487-1488. According to legend, its name comes from the miracle-working Icon of the Annunciation of the Holy Virgin, which was once kept here. In 1731, the Church of the Annunciation, which has not survived, was added to this tower. The height of the tower is 30.7 meters (32.45 meters with the weather vane).

Troitskaya Tower

The Troitskaya (Trinity) Tower, the tallest of the Kremlin towers, was regarded as second to the Spasskaya Tower in significance. Built in 1495, it was first named Bogoyavlenskaya (Epiphany) and then, later on, Znamenskaya (after the Icon of the Mother of God "The Sign"). In 1685, by Czar Alexei Mikhailovich's *ukase*, it was renamed Troitskaya after the *podvorye* (representation) of the Trinity Monastery situated in the vicinity.
In 1516, a stone bridge which connected the Troitskaya Tower with the Kutafya Tower, a bridgehead watchtower on the other bank of the Neglinnaya River that served as a moat, was built over the river. The gates of the tower served as the entrance leading to the palace of the czarina and the princesses and to the Patriarch's Chambers. The clergy came through these gates to greet czars returning victorious from campaigns. It was also through the Troitskiye Gates that Napoleon's troops entered, and later fled from the Kremlin.
In 1685, a multitiered superstructure reminiscent in outline of the upper part of the Spasskaya Tower was added to the tower. On the sides of its massive lower part there are decorative turrets with weather vanes, and pointed arches. In 1686, a clock was mounted on the tower, but it was badly damaged in 1812 and was never restored.
The tower, crowned with a ruby star, is 76.35 meters in height (80 meters to the top of the star).

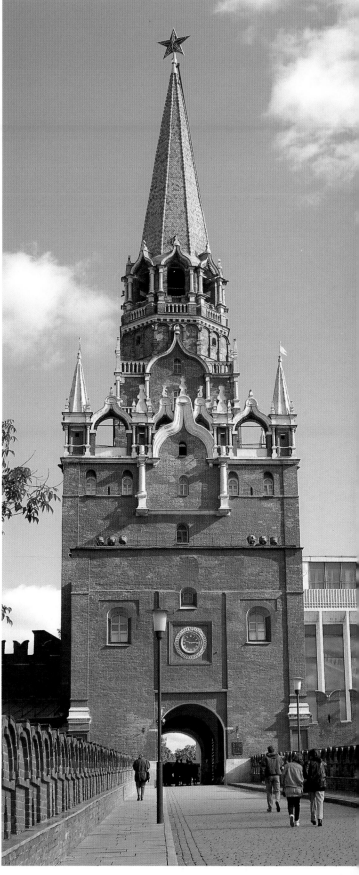

The Troitskaya Tower.

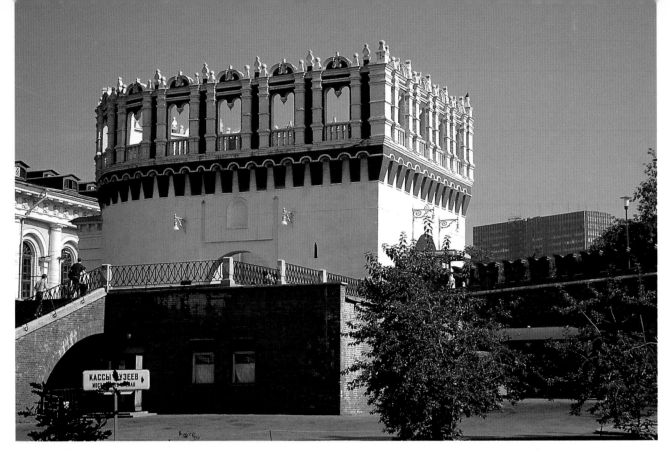

The Kutafya Tower.

Kutafya Tower

In 1516, the Kutafya Tower was built at the other end of the Troitsky Bridge opposite the Troitskaya Tower, under the supervision of the Milanese architect, Alevisio Fryazin.

This low-built tower with machicolations and embrasures, surrounded by a moat and the Neglinnaya River, was a formidable obstacle to the advancing enemy. Its name, Kutafya, comes from the word *kut*, meaning "nook" or "shelter".

The Kutafya Tower never had any roof. In 1685, it was topped with an openwork whitestone crown. The tower is 13.5 meters high.

Srednyaya Arsenalnaya Tower

This tower was built in the 15th-16th centuries on the site of a corner tower of the Kremlin dating from the reign of Grand Duke Dmitry Donskoi. It was given its present name, meaning the Middle Arsenal Tower, after the building of the Arsenal was erected next to it in the early 18th century. The outer side of the tower is divided by two flat vertical niches.

In 1680, an open lookout with a small pyramidal top was added to the tower. In 1821, a grotto, one of the attractions of the Alexandrovsky Gardens, was built at the foot of the tower to the design of Osip Beauvais. The tower is 38.9 meters high.

Komendantskaya Tower

In 1495, the Kolymazhnaya (Coach) Tower, named after the Coach Yard situated next to it inside the Kremlin, was built on the southern side of the Troitskaya Tower. In the 19th century, when the commandant of Moscow took up residence in the Kremlin's Poteshny Palace situated nearby, it began to be called its present name, the Komendantskaya (Commandant's) Tower. The height of the tower on the side of the Alexandrovsky Gardens is 41.25 meters.

Oruzheinaya Tower

On the southern side of the Komendantskaya Tower is the Oruzheinaya (Armory) Tower, known at one time as the Konyushennaya (Stable Yard) Tower. It was built next to the royal Stable Yard in 1493-1495. The tower was given its present name in 1851, when the building of the Armory which we now see was erected in the Kremlin. In 1676-1686 a superstructure was added to the tower, which is 32.65 meters high.

Uglovaya Arsenalnaya Tower

This third corner tower of the Kremlin, situated next to the entrance to the Alexandrovsky Gardens, was built by the architect Pietro Antonio Solari in 1492. It is

the most monumental of the Kremlin defensive structures. Its walls, which are four meters thick, are divided into 16 sides. Its deep basement, which can be reached by an inner stairway, conceals a well filled with crystal-clear spring water, which is still in existence today. Originally it was named the Sobakina Tower after Boyar Sobakin whose manor was situated nearby. The tower was given its present name, meaning the Corner Arsenal Tower, after the Arsenal was built next to it in the 18th century. In 1672-1686, an octagonal superstructure with a pyramidal octagonal top crowned with a small hipped roof and a weather vane was built on this tower. In 1812, the top part of the tower was torn off by a blast and the tower itself developed cracks. The tower was finally restored in 1946-1957. The height of the tower is 60.2 meters.

Senatskaya Tower

In the center of the northeastern side of the Kremlin wall stands the Senatskaya (Senate) Tower built in 1491 between the Frolovskaya (now Spasskaya) and Nikolskaya Towers by the architect Pietro Antonio Solari. It remained nameless until the late 18th century, and it was only after the building of the Senate was completed in the Kremlin that it was given its present name. In 1680, a tentlike stone superstructure crowned with a gilt weather vane was built on top of this blind, square tower. Its height is 34.3 meters.

Petrovskaya Tower

Next to the Beklemishevskaya Tower stands the Petrovskaya Tower named after the Church of St. Pyotr, Metropolitan of Moscow and All Russia, which was situated not far from it. Just as the two Nameless Towers, it was built between 1488 and 1490. In 1812, it was almost completely destroyed by the explosion of a powder-filled cannonball, but in 1818 it was restored under the supervision of the architect Osip Beauvais.
The tower is 27.15 meters high.

A view of the Kremlin from the Moskva River.

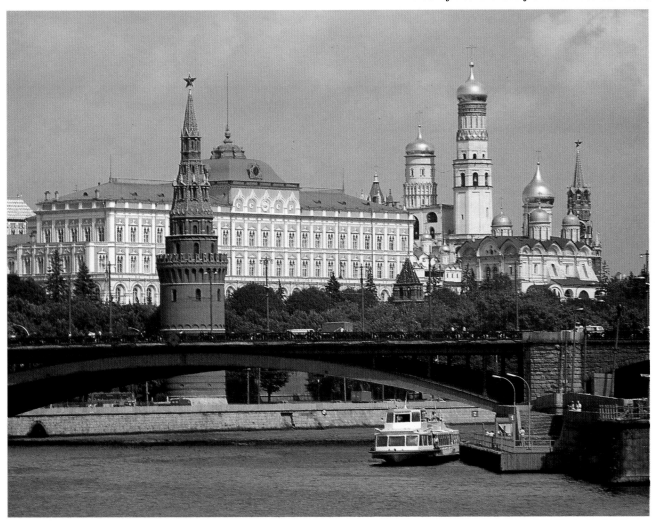

CATHEDRAL SQUARE

The architectural monuments of the Moscow Kremlin by right rank among the crowning achievements of human genius. They are a precious blend of inspired art and technical perfection incorporating the efforts of several generations of outstanding masters of their day — architects and sculptors, engineers and artists — who handed down a priceless legacy to future generations. The ensemble of monuments of church and civil architecture adorning the ancient Kremlin has largely preserved its medieval appearance in which the traditions of early Muscovite architecture and of various local Russian architectural schools, as well as the finest achievements of Italian masters merged to form a harmonious whole. They surround the Kremlin's main square that has witnessed all the most important events in the history of the Russian state. In old documents, Cathedral Square

Cathedral Square of the Kremlin. In the center: the Czarina's Golden Chamber and the Palace of Facets. Miniature and text from the book "Election to the Throne". 1672-1673.

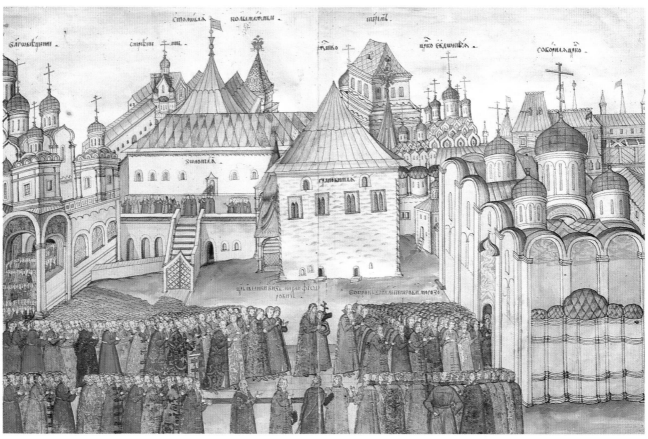

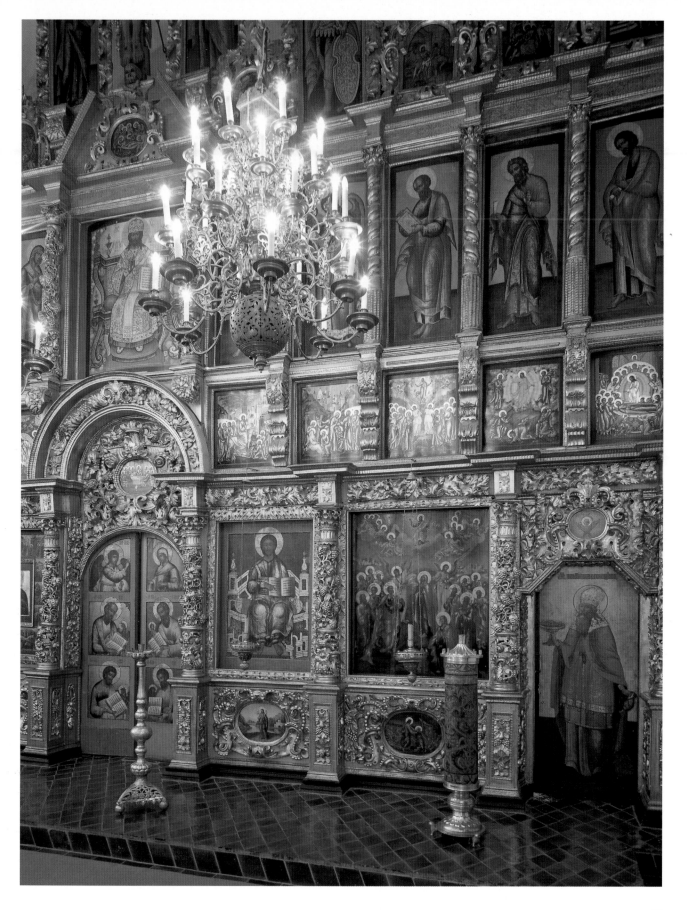

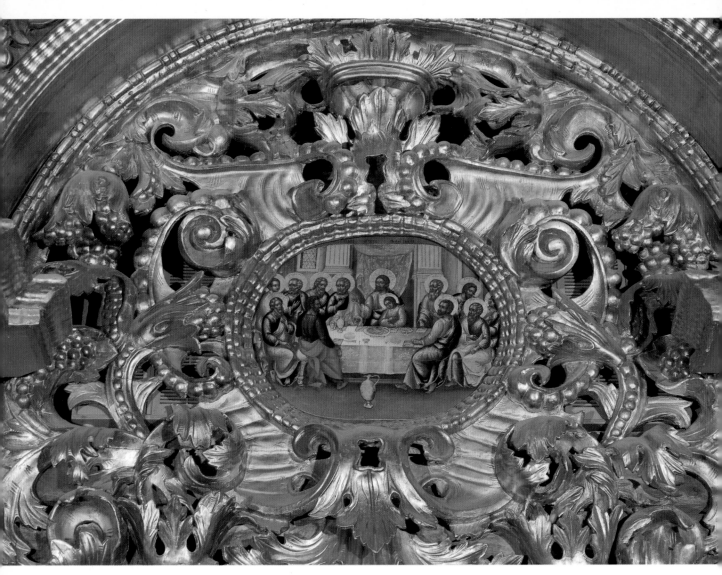

Two details of the Holy Door of the Church of the Twelve Apostles.

"red", or best, corner. Broad benches decorated with bright valances were an indispensable part of furnishings in every house. Chests were used for storing household goods.

Changes in the traditional way of life that Russian society began to undergo in the second half of the 17th century brought in their wake changes in the interiors of rich dwellings where, in a contemporary's phrase, "the old and the new were blended together". Now a Dutch wardrobe, a German cupboard and chairs copied from foreign models could be seen alongside traditional furniture and portraits of Peter the Great, Prince Potemkin and Czar Alexei Mikhailovich were hung next to icons. On show in the *Refectory* of the Patriarch's Palace is a collection of Old Russian subject and ornamental gold embroidery by Russian needlewomen. Works of this singular art were made for a wide variety of use and included covers for sacred vessels, the *epitaphios* (winding sheet) — a special icon painted or embroidered on

cloth depicting the dead Savior, and icon cloths. All of them adorned the interiors of churches at one time. In the 17th century, pearls and gemstones began ever more often to be used in decorating icon cloths. One of the most remarkable examples of subject embroidery dating from that period is the icon cloth with the Vladimir Icon of the Mother of God, produced at the Czarina's workshops in the Kremlin, from the sacristy of the Cathedral of the Dormition. It is reminiscent of an icon in a rich mounting adorned with pearls and gems. One of the most interesting sections of the museum's display is the **Church of the Twelve Apostles**. An integral part of the architectural complex of the Patriarch's Palace, it used to be a domestic church of the Russian patriarchs. Its interior kept changing over the centuries: the windows were widened and the iconostasis was renovated. In setting up the museum display, the restorers to a certain extent re-created its late 17th century interior.

50

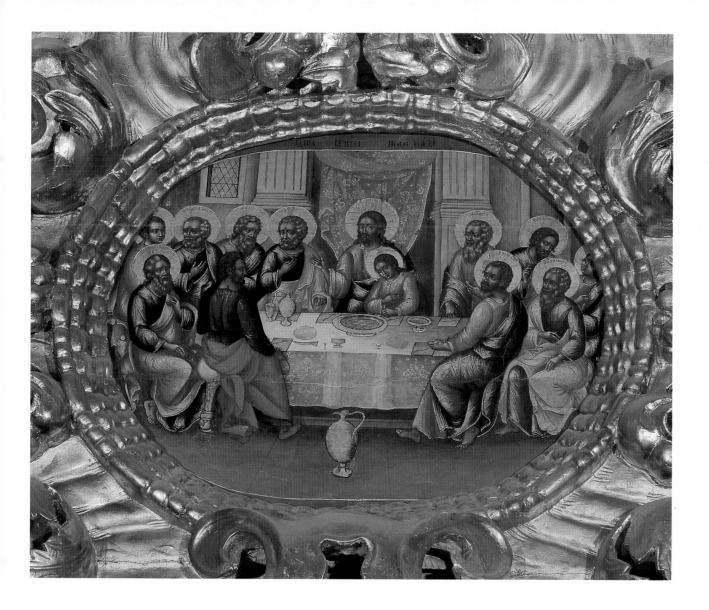

The old iconostasis has not survived. The one that is to be seen here today is from the cathedral of the Kremlin's Convent of the Ascension, which has not come down to us. The iconostasis was transferred into the Church of the Twelve Apostles in 1929. The splendid five-tiered iconostasis of gilt carved wood, made in the traditions of the late 17th century style known as the Moscow baroque, features a strikingly great variety of ornamental motifs and an expressive plastic treatment. Its magnificent, rich ornamentation includes realistically represented flowers, leaves, fruits and berries. The most prominent motifs are a climbing grapevine and cartouches. Inside the church there is a unique exhibition of 17th century icons most of which used to belong to the Kremlin workshops or adorned the Kremlin cathedrals. The display is arranged according to a chronological principle, making it possible for the visitor to form an idea of the development of one of the trends of Russian icon-painting in the first half of the 17th century known

as the Stroganov school of icon-painting, and of the work of royal painters in the second half of the 17th century.

Stroganov icons, which were painted for connoisseurs of the fine arts, "elevated the soul" and "pleased the eye". The name "Stroganov school" is linked with the Stroganov family, who were eminent industrialists and patrons of the arts and who had their own icon-painting workshops in the town of Solvychegodsk in the Urals. From the 1660s to the end of the 17th century, a departure from the traditional Old Russian style was observed in Russian icon-painting. Thus, in the work of such well-known painters of the period as Simon Ushakov and Fyodor Rozhnov — in particular, in their icons *St. Theodore Stratilates*, *St. Andrew the First-Called*, *The Crucifixion*, and others — a leaning towards what later became known as realistic art, with a marked interest in contemporary life, in man and nature, is to be clearly seen.

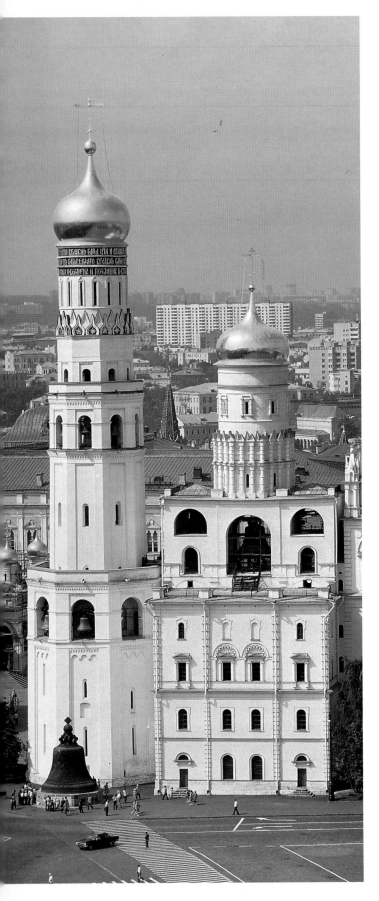

THE IVAN
THE GREAT BELL TOWER

The focal point of the Kremlin architectural ensemble is the Ivan the Great Bell Tower. Together with the adjoining campanile and the Filaret Annex, it marks the boundary of the Kremlin's Cathedral Square on its eastern side.

Originally the bell tower, built by the architect Bon Fryazin in 1505-1508, consisted of the two lower tiers and, partially, the third tier of the presently existing tower and was 60 meters high. Already then it occupied the dominating position in the architectural ensemble of Cathedral Square. It was given its name, "Ivan", after St. John Climacus to whom the church inside the first tier of the bell tower is dedicated, and was dubbed "the Great" on account of its unusually great height. In the days of old, this immense structure served as the Kremlin's watchtower and signal tower.

In 1600, Czar Boris Godunov ordered to add another tier on top of the bell tower, which, after it had been completed, reached a height of 81 meters. There is a gilt inscription in Old Slavonic below the dome of the bell tower telling about the event.

In 1532-1543, the architect Petrok Maly built a campanile close to the northern façade of the bell tower and in 1624 the Filaret Annex was added to the Ivan the Great complex. All these structures, dating from different periods, merged into a picturesque composition forming a single architectural whole.

When retreating from Moscow in 1812, Napoleon ordered the Ivan the Great Bell Tower to be blown up, but the magnificent structure withstood the blast. In 1814-1815, the entire architectural ensemble was restored.

Altogether there are 21 bells dating from the 16th to 19th centuries in the bell tower and campanile. The bells are not only ancient musical instruments, but also highly artistic examples of monumental casting perpetuating the names of such outstanding Russian founders as Fyodor and Ivan Motorin, Andrei Chokhov, Filipp Andreyev, and Vassily and Yakov Leontiev.

It was customary then to give special names to particularly revered bells. The Kremlin collection boasts the Dormition Bell, the New Bell, the Reut, and others.

On the ground floor of the campanile there is an exhibition hall where displays of works of decorative and applied art from the collections of the Moscow Kremlin State Museum-Reserve of History and Culture are arranged.

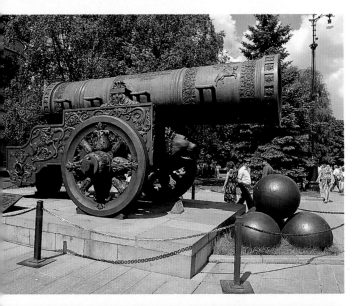

THE CZAR BELL
AND THE CZAR CANNON

On Ivanovskaya Square of the Kremlin, two world-famous attractions, two outstanding examples of monumental art casting — the Czar Bell and the Czar Cannon — are to be seen.

The **Czar Cannon** is a fine example of the craftsmanship of 16th century Russian founders. It was cast in bronze by master Andrei Chokhov at the Cannon Yard in Moscow in 1586, in the reign of Czar Feodor Ioannovich, the son of Ivan the Terrible. The cannon weighs 40 tons, is 5.34 meters long and has a caliber of 890 mm, which makes it the largest gun in the world: hence its name. The cannon was intended for defending the Moscow Kremlin and was originally placed near the Spasskiye Gates. The cannon, however, was never fired. The surface of its barrel is decorated with an ornamental pattern and raised inscriptions one of which describes the history of making it. On the barrel there is also a cast likeness of Czar Feodor Ioannovich on horseback, clad in royal vestments and holding a scepter in his hand.

In 1835, a decorative iron gun carriage embellished with a cast ornamental pattern was cast for the Czar Cannon at the Byrd Works in St. Petersburg to the design of the architect Alexander Bryullov. The cannonballs lying nearby, weighing one ton each, are also decorative, for the cannon was designed to fire not cannonballs but grapeshot.

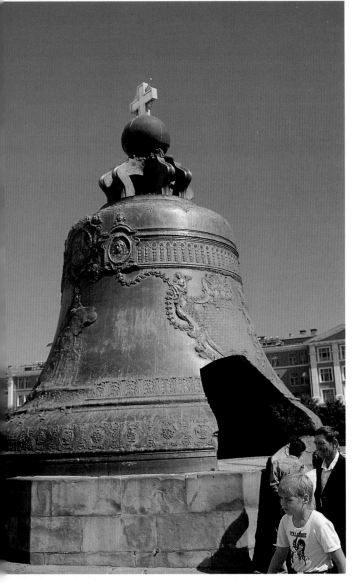

At the foot of the Ivan the Great Bell Tower stands the famous **Czar Bell** — a unique example of Russian foundry work cast in 1733-1735 in the Kremlin by the noted Moscow founder Ivan Motorin and his son, Mikhail. Russian craftsmen V. Kobelev, P. Galkin, P. Kokhtev and P. Serebryakov skillfully worked the surface of the bell in relief with decorative patterns, embossed pictures, and inscriptions. The figures of Empress Anna Ioannovna and Czar Alexei Mikhailovich are in a central place. The inscriptions telling about the history of making the bell are enclosed in decorative cartouches in the shape of baroque scrolls and angels. During the great fire of 1737 the Czar Bell still lay in its casting pit. Because of uneven cooling, which resulted from the attempts to extinguish the fire, the red-hot bronze of the bell cracked and a chunk weighing 11.5 tons broke off. After the fire the bell remained in the pit for almost 100 years. It was only in 1836 that it was raised and put on a granite pedestal under the supervision of the architect Auguste Montferrand.

The Czar Bell is the largest bell in the world: it weighs over 200 tons and is 6.14 meters high and 6.6 meters in diameter.

In 1980, the bell was restored and cleared of later layers of paint and patina, and its pedestal was reinforced. Today the technical condition of this unique masterpiece continues to be thoroughly monitored by scientists. It is being preserved as a priceless museum piece.

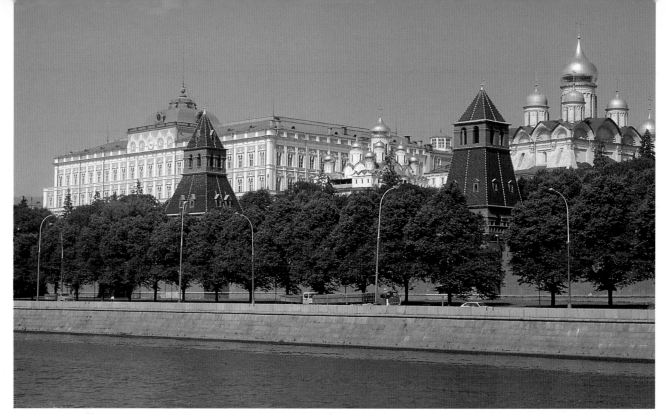

A view of the Grand Kremlin Palace from the Moskva River.

THE ENSEMBLE OF THE GRAND KREMLIN PALACE

One of the universally recognized architectural master-pieces of the Moscow Kremlin is the majestic building of the Grand Kremlin Palace, built on the crest of Borovitsky Hill in the southwestern part of the Kremlin, which once was the site of the grand dukes' and later, of the czars' residence. It is a complex conglomerate of civic and church structures dating from the various periods of the shaping up of the Kremlin architectural ensemble. In medieval Russia, a palace meant a complex of estate structures with staterooms and private chambers, churches, workshops, and service buildings.

The inexorable course of time, numerous fires and national calamities did not spare the ancient Kremlin structures, and by the end of the 18th century they became dilapidated. The construction of a new official residence that would meet the requirements of the imperial family was launched in 1838 and continued for twelve years.

The main façade of the palace faces the Moskva River. A group of architects headed by the well-known St. Petersburg architect Konstantin Ton (1794-1881) were commissioned to design and build the palace. A number of prominent Moscow architects such as F. F. Richter, N. I. Chichagov, P. A. Gerasimov, and others also took part in its construction. Their outstanding talent and exceptional professional skill helped them to successfully solve the complicated problem of combining such distinct Kremlin structures dating from different periods (14th-17th centuries) as the Palace of Facets, the Czarina's Golden Chamber, the Terem Palace and the palace churches, as well as the newly-built 19th century Grand Kremlin Palace into a single whole.

Although quite modern in its layout and structural design, the palace was made to reproduce the style of centuries past.

The various parts of the complex appear to be forming a single whole thanks to the asymmetrical multitier arrangement of its individual sections. The palace is covered with a hip roof and has a rectangular attic topped with a dome. The terraces projecting from its main and eastern façades are reminiscent of Old Russian promenades. A link with the Old Russian tradition is to be particularly clearly seen in decorating the palace building with carved whitestone pediments and platbands over the window openings with double arches connected by a tie piece "hanging" in the middle. The grand entrance to the palace is organically blended into the general rhythm of the archways of the palace's southern façade.

The Grand Kremlin Palace surpassed many of the contemporary European palatial structures in monumentality and splendor. Its main façade is 125 meters long and 44 meters high. The palace contains nearly 700 separate rooms with a total floor area of about 20,000 square meters. The building appears to be three storieshigh, but in fact there are only two, the upper having its windows in two tiers.

The socle of the palace's brick walls is faced in gray stone and the cornices and platbands of its windows are made of white limestone.

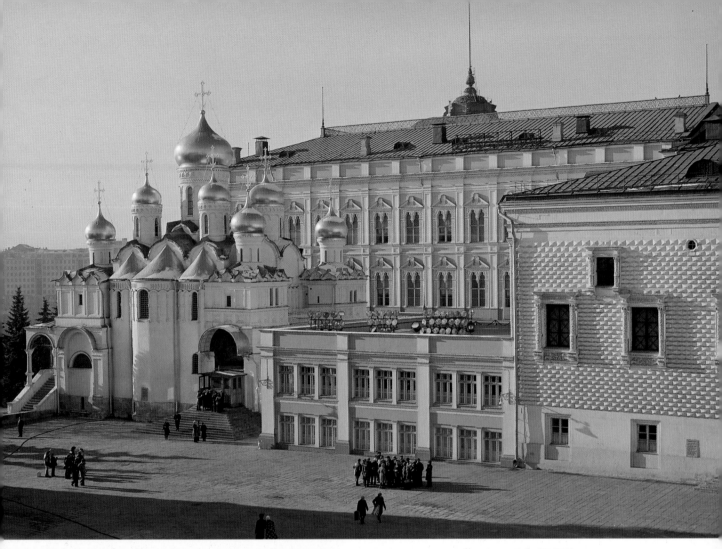

THE PALACE OF FACETS

The Palace of Facets, the ceremonial throne hall of Grand Duke Ivan III, occupies the central place in the immense complex of the Grand Kremlin Palace structures. Its history began after Ivan III, who proclaimed himself "ruler of all Russia", was enthroned in 1462. In 1472, he married Byzantine princess Sophie (Zoe) Palaeologa. At the time, construction work was launched in the Kremlin on a grand scale. Presumably, it was then that the Italian architects Marco Fryazin and Pietro Antonio Solari came to Moscow. The construction of the royal palace began in 1485 and was completed in 1508, after the death of Ivan III. It was his son, Grand Duke Vassily III (r. 1505-1533), who became the first occupant of the palace. In the second half of the 16th and in the 17th centuries, under Ivan the Terrible, Boris Godunov, and the first czars of the Romanov dynasty, the palace was altered more than once. The Palace of Facets is the only part of the great and splendid 15th century palace that has come down to us. Its main façade overlooks Cathedral Square where in olden times ceremonial processions during the coronation of the czars were held and foreign ambassadors were greeted. The façade is finished in faceted white stone, from which the name derives. Originally the palace was topped

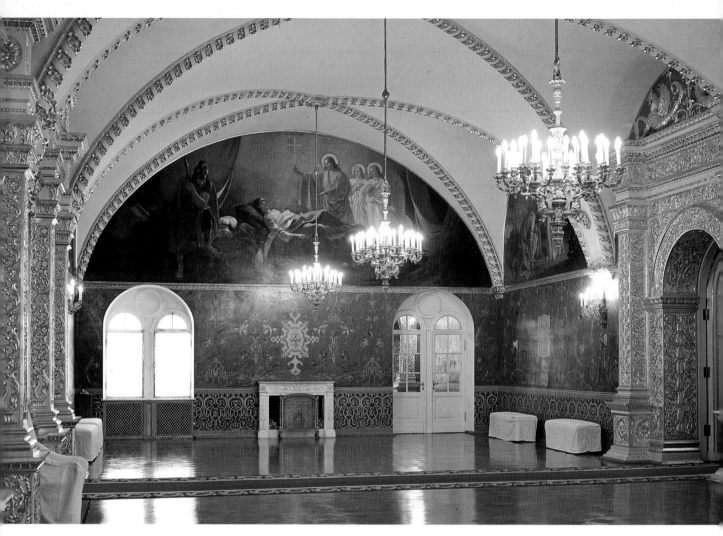

The Palace of Facets. The Sacred Vestibule.

The carved whitestone portal.

with a high copper hip roof, which is to be seen in a miniature from the book *Election of the Great Sovereign Czar and Grand Duke Mikhail Feodorovich to the Throne*, dating from 1672. In the course of the next three centuries, the appearance of the building kept changing. In particular, in 1684, after a fire in the Kremlin, its high roof was replaced with a low one made of iron and its old windows were widened and embellished in a lush manner characteristic of the baroque style. The carved platbands around the windows are made of white stone, the round columns on either side of each window are decorated with carved ornamental patterns in the shape of a grapevine, and figures of lions made in relief are placed between the bases of the columns.

In olden times, the *Krasnoye (Red) Porch*, a grand entrance with a staircase leading to the *Sacred Vestibule*, an anteroom at the entrance to the reception hall, adjoined the Palace of Facets. Here people invited for a royal audience waited to be received by the czar. Six whitestone portals lavishly decorated with carving and gilt lend the Sacred Vestibule a particularly distinct look, which is made even more festive by wall paintings

featuring Biblical and historical themes. The original ancient murals did not survive and were reproduced by painter Fyodor Zavyalov in 1847.

The hall has an area of 500 square meters, which made it the largest hall in Moscow in its day, and is 9 meters high.

Its groined vaults are supported by a massive central pillar, which is richly decorated with gilded whitestone carving showing dolphins, birds and animals. No less impressive is the decoration of the portal of the Palace of Facets with a stylized floral pattern and representations of fantastic animals.

The interior decoration of the hall changed often in the five centuries of its existence. It was painted for the first time in the late 16th century in the reign of Czar Feodor Ioannovich, the last czar of the Rurik dynasty. In the late 17th century, the old murals, which had become dilapidated, were removed and the walls were covered with red broadcloth. In 1881, during preparations for the coronation of Emperor Alexander III, it was decided to paint the hall of the Palace of Facets anew according to descriptions of the 16th century subjects and compositions compiled by the noted Russian painter

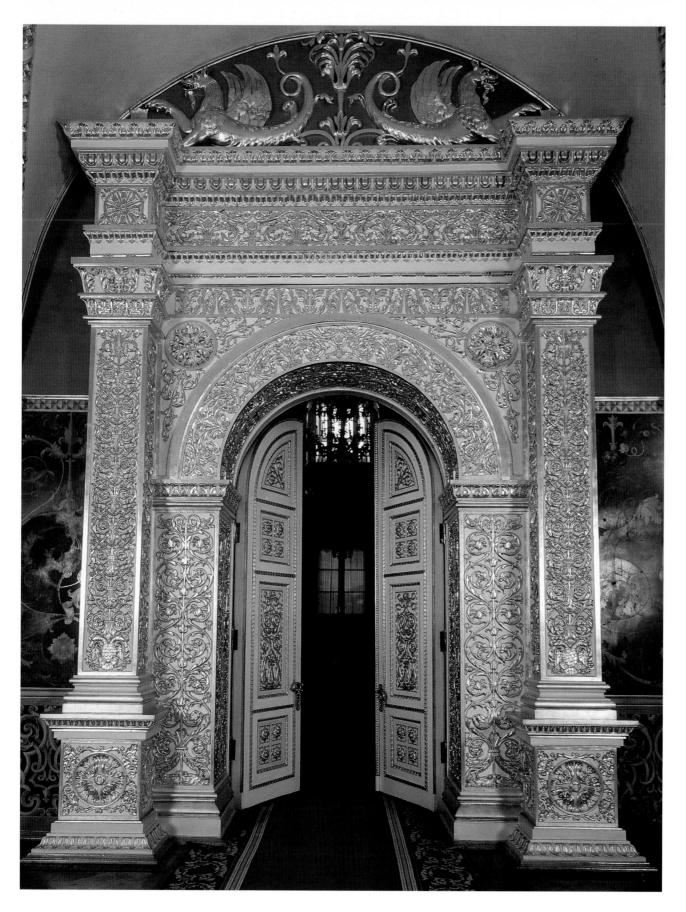

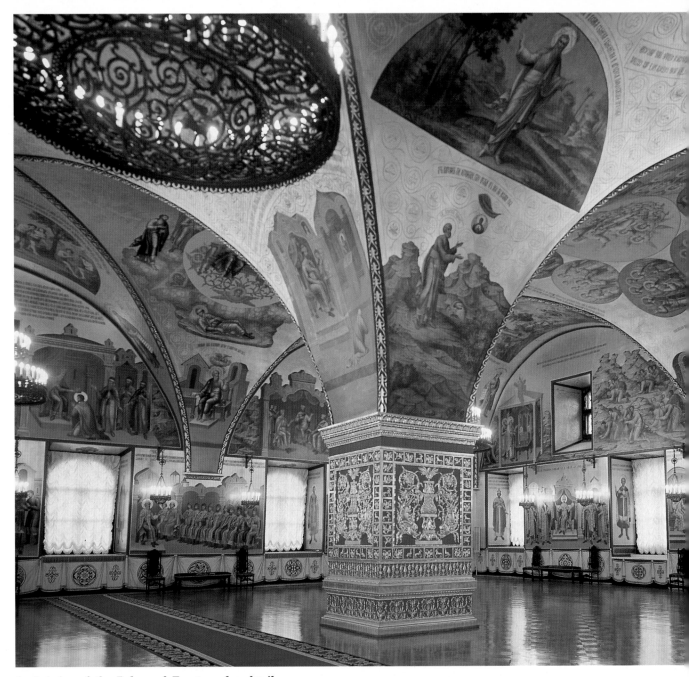

*An interior of the Palace of Facets and a detail
of the painting portraying the Russian princes.*

Simon Ushakov in 1676. In 1882, the Belousov brothers, masters from Palekh (a village renowned for its distinctive paintings), reproduced the wall paintings in the hall on the basis of 16th century iconography. On the ancient vaults and window bays, compositions on Biblical subjects about the creation of the universe are painted in thirteen circles and semicircles. Also shown on the vaults, representing, as it were, a transition from the heavenly kingdom to the earthly world, are figures of prophets, forefathers, and the Evangelists with scrolls in their hands.

The paintings on the walls illustrate Biblical subjects and scenes from Russian history.

The eastern wall occupies a special place in the decorative scheme of the hall because the czar's throne used to stand in the southeastern corner. The paintings on the eastern and part of the southern wall feature subjects from the *Tale of the Princes of Vladimir* epitomizing the idea of the historical continuity and legitimacy of the power of the Moscow princes. One of the compositions shows the first Rurik princes, who were believed to be descended from the Roman emperor Augustus, and Grand Duke Vladimir of Kiev during whose rule Russia adopted Christianity in 988 A. D. On the southern wall the composition *Handing of Royal Regalia to Vladimir Monomakh* and, next to it, portraits of Czar Feodor,

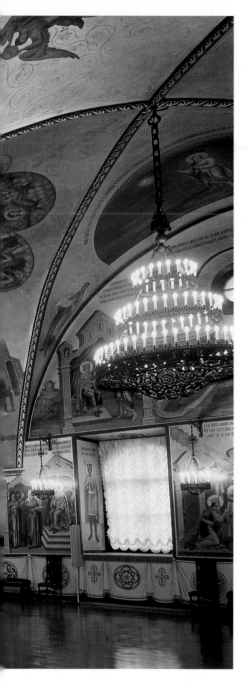

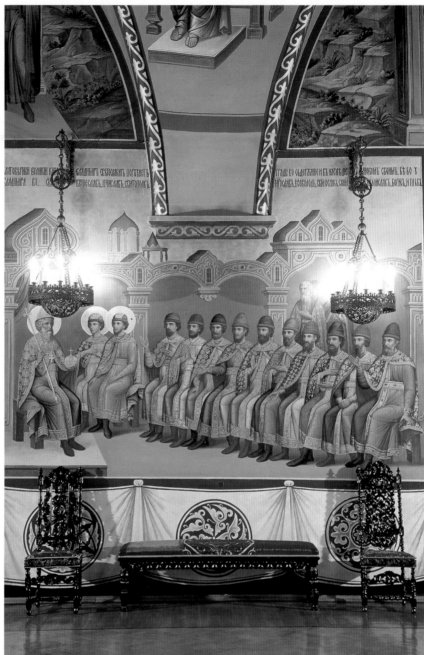

the son of Ivan the Terrible, and Czar Boris Godunov can be seen. The window bays are adorned with likenesses of twenty-four Russian rulers who won fame for their Motherland.

In the murals decorating the walls of the Palace of Facets parallels between Old Testament subjects and events of Russian history can be seen, such as the story of the ascension of Czar Boris Godunov to the throne and the story of Joseph from the Old Testament. Compositions on the subject of the righteous and unrighteous judges are painted on the western wall opposite the place where the royal seat used to be.

The ceremonial hall of the Palace of Facets was intended for holding various formal functions. The sittings of the Zemsky Sobor (National Assembly) and the Boyar Duma (Noblemen's Council) took place in this hall, foreign ambassadors were received, heirs to the throne were announced, major historical events were celebrated and elaborate feasts and receptions were held here. Around the central pillar near which *postavtsi* — special cupboards for holding ceremonial tableware — stood, top-ranking noblemen, boyars, clad in fine garments of velvet or brocade and wearing tall sable hats used to sit on benches placed along the walls.

The year 1991 saw the 500th anniversary of this gem of Russian architecture, the Palace of Facets.

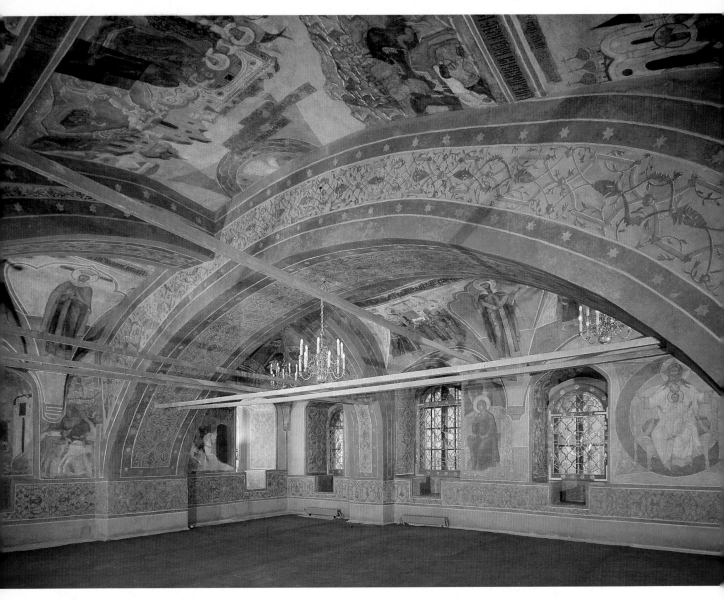

THE CZARINA'S GOLDEN CHAMBER

Situated next to the Palace of Facets is the Lesser
Golden Chamber, part of the former Ivan the Terrible's
palace. It is a small room with low vaults and arches.
The exact time when the Czarina's Chamber was built
is not known, nor the names of those who built it.
From the surviving fragments of whitestone carving,
however, it may be presumed that they were master
builders familiar with Italian Renaissance architecture.
The first mention of the Russian czarinas' reception
hall date from the 1580s, the reign of Czar Feodor
Ioannovich (r. 1584-1598) and his spouse, Irina Godu-
nova. It was then that this hall was named the Czarina's
Golden Chamber. This ceremonial reception hall was
intended for use by czarinas. It was the place where
ceremonies in connection with the weddings of august
personages and funeral repasts in memory of deceased
czarinas were held and representatives of the Russian
and foreign clergy were received. At the highest point
of the vault the Image of the Mother of God "The

Sign", epitomizing the triumph of the Christian ideas,
is painted. This is not accidental, for veneration of the
Virgin had by then become a tradition.
The murals painted against a golden background are of
immense artistic and iconographic interest. They portray
royal women saints and depict their deeds. In particular,
scenes from the life of Princess Olga of Kiev, the first
Christian Russian princess, *St. Dinara*, the Georgian
queen who won a victory over the Persian shah in the
11th century, and *St. Theodora*, the wife of Emperor
Theophilus the Iconoclast of Byzantium, are to be seen here.
In the early 17th century, after the fires and devastation
that Moscow endured during the Time of Troubles, the
building of the Czarina's Golden Chamber, just as all
the other palatial structures in the Kremlin, was in need
of repair. In the course of the 17th century, its murals
were renovated more than once. In 1796, during prep-
arations for the coronation of Emperor Paul I, the murals
were repainted in oil and later on, during the construction
of the new palace in the 19th century, they were
restored.

The Czarina's Golden Chamber. The vault painting: the composition "The Journey of Princess Olga of Kiev" and "Hagia Sophia".

Subsequently Kremlin restorers, working for eight years (1970-1978), carried out the complicated and intricate task of removing the later layer of painting to reveal the original murals that once adorned the Czarina's Golden Chamber.

The wall paintings in the Palace of Facets and the Czarina's Golden Chamber were quite innovative in their day. Thus, symbolic and allegorical pictures featuring the seasons of the year, the signs of the zodiac, as well as the virtues and prophets were introduced alongside traditional Biblical and historical subjects.

In the 16th century, the schemes of interior decoration of secular palatial halls developed along more realistic lines in that the place of the somewhat abstract murals of the earlier centuries was now taken by what might be called narrative paintings. The subject of each mural was based on a literary source that was quite familiar to the contemporaries.

The wall paintings recently uncovered by restorers in the Czarina's Golden Chamber have made it possible to appreciate the true beauty and splendor of the Russian czarinas' throne hall which is, perhaps, the only monument of 16th century Russian secular monumental painting to have survived to this day.

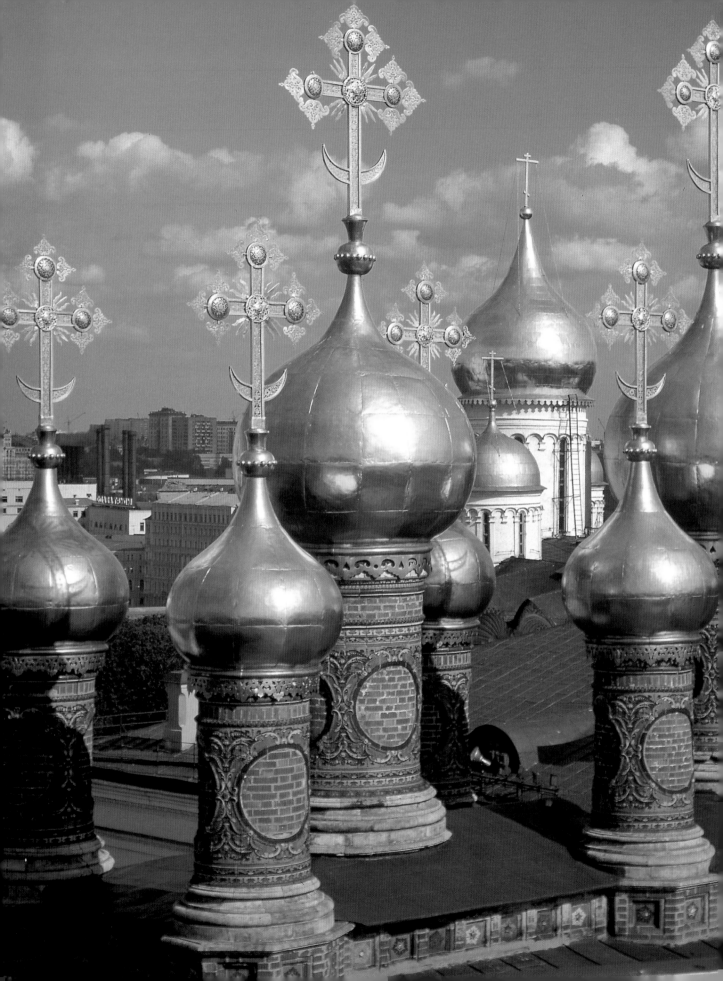

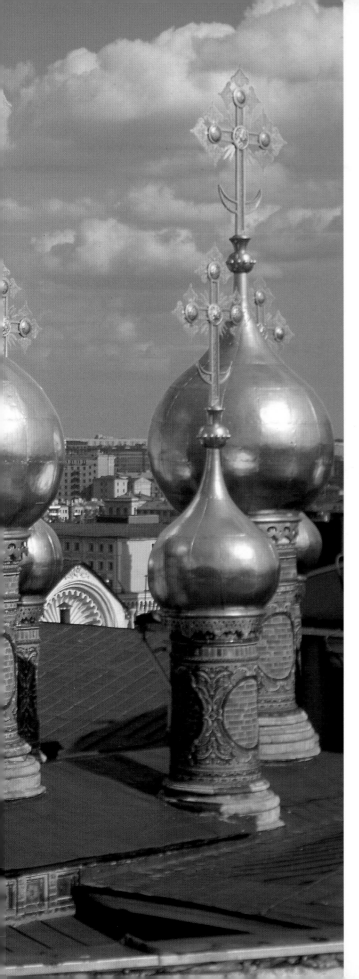

THE TEREM CHURCHES

The ensemble of the Grand Kremlin Palace includes a group of small churches. Known as the Terem churches, they were built in the period between the 14th and 17th centuries. Originally there were eleven of them, but only six remained after numerous alterations made in the 18th and 19th centuries.

The oldest of them, dating from 1393, is the Church of the Nativity of the Virgin, renamed the **Church of the Resurrection of Lazarus** in the early 16th century. Walled up and turned into the crypt of the Church of the Nativity built over it by Alevisio Novy in 1514, it is today the only one of the Kremlin structures to give you an idea of 14th century Moscow architecture. In the course of the next three centuries the upper church was altered more than once; in particular, it underwent major alterations during the construction of the Grand Kremlin Palace in the 19th century. It was also then that its old murals were covered by oil painting, and only the icons in the bottom tier of its 17th century iconostasis have survived to this day.

In 1635-1636, court architects built a church dedicated to the Image of the Savior "Not Made with Hands", known as the **Verkhospassky Cathedral** (Upper Cathedral of the Savior), the main domestic church of Czar Mikhail Feodorovich Romanov. The most interesting thing to be seen in this church is its carved gilt wooden iconostasis made by Russian artists in the second half of the 17th century. Of particular interest are paintings by Fyodor Zubov, the noted painter, done in his characteristic free, artistic, radiant manner.

No less valuable is the interior decoration of the **Church of the Resurrection of Christ** with its lacy high-relief carved iconostasis adorned with gleaming gilt ornamentation. Its color palette is quite unusual with carved ornamental pieces, coated with pigmented varnish, that are made in relief and laid on a plain turquoise-blue background. Such a combination of painting and carving in relief is only to be found in the Church of the Resurrection of Christ. It has no parallel among the 17th century works of art that have come down to us. Not only icons for this church, but also its walls and vaults were painted by first-rate painters.

The domes of the Terem churches.

On the next pages: left: the iconostasis of the Verkhospassky Cathedral; right: the iconostasis of the Church of the Resurrection of Christ.

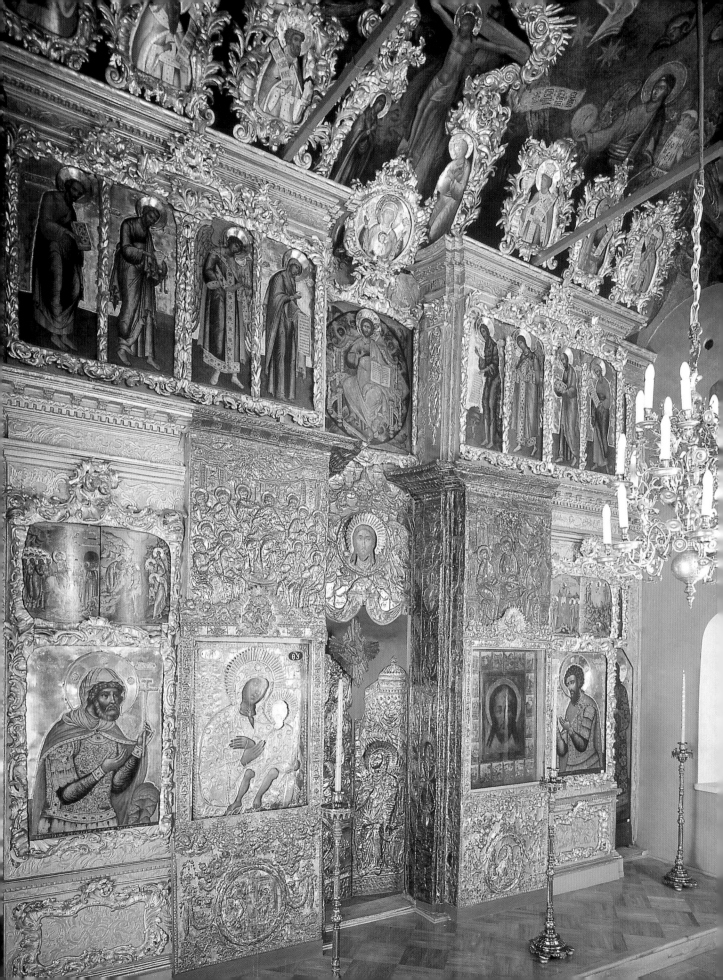

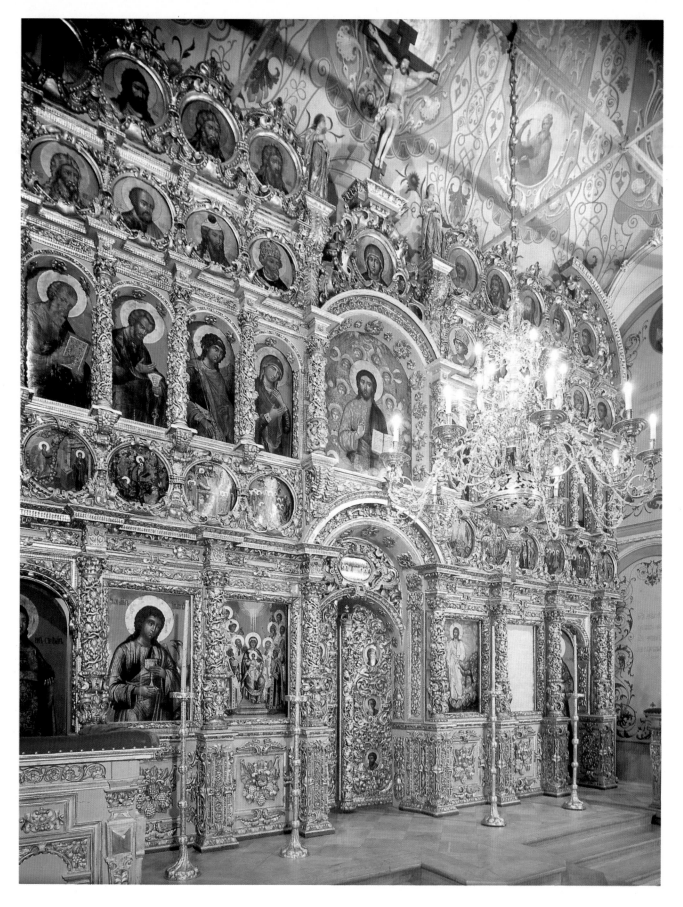

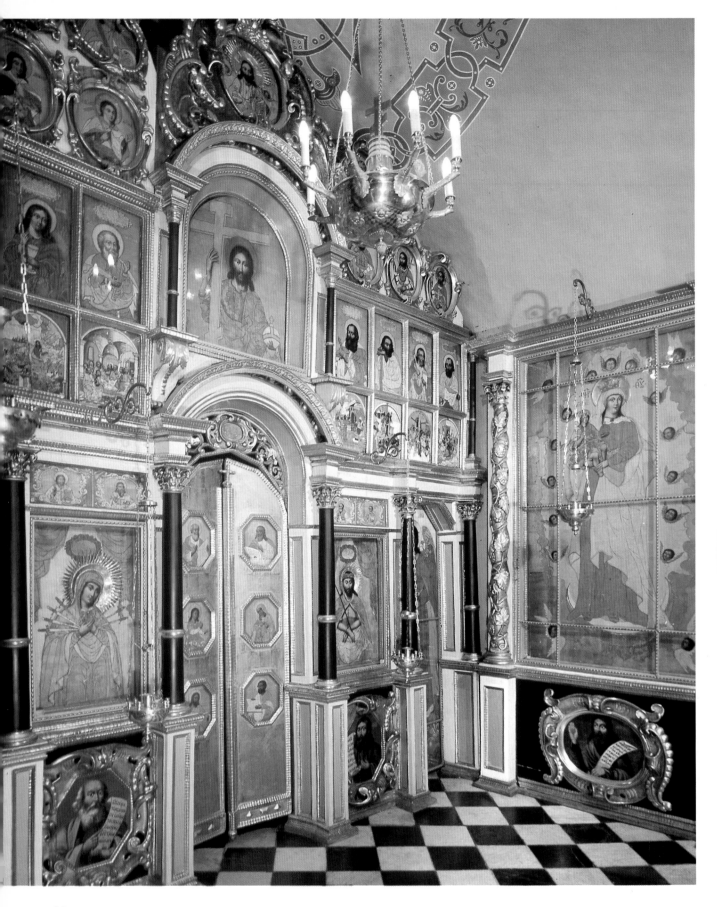

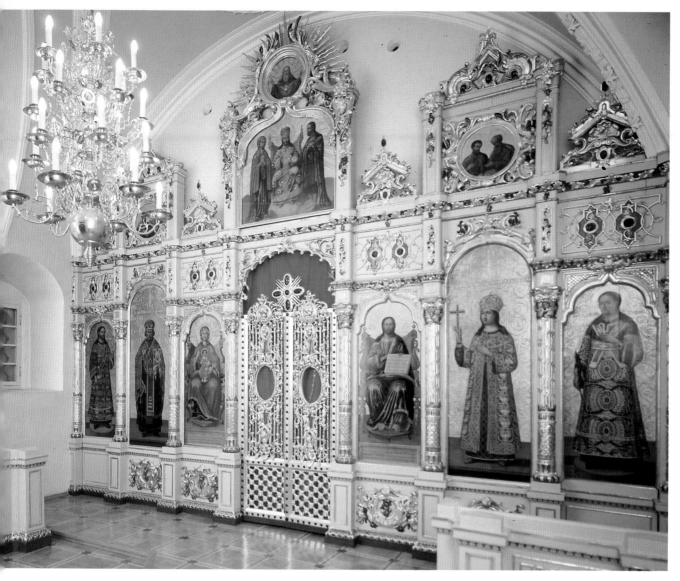

The iconostasis of the Church of the Crucifixion.

The iconostasis of the Church of St. Catherine.

In 1682, on the *ukase* of Czar Fyodor Alexeyevich, a small **Church of the Crucifixion** was built next to the Church of the Resurrection of Christ. Its iconostasis, also without parallel, was executed by Vassily Poznansky, an artist who had a style all his own. The distinctive feature of the iconostasis is its appliqué icons. This rare technique involves the gluing of pieces of fabric to a wooden base. The faces of the saints in the icons are painted in oil and everything else is made of pieces of West European and oriental fabrics. Thanks to the use of this singular technique, the icons have a distinct, festive appearance.

One of the Terem churches of the Grand Kremlin Palace, the **Church of St. Catherine**, built by the architect John Taler in 1627-1628, was intended to serve as the private chapel of the czarinas and princesses. The great fire of 1737 destroyed both of its iconostases and only the building itself has survived to this day.

On Cathedral Square, west of the Church of the Deposition of the Virgin's Robe, a multi-cupola gilded roof common to four of the domestic churches can be seen. It was built in 1683. Its eleven cupolas are crowned with openwork gilded crosses. The roof is decorated with a tiled frieze and a similar frieze decorates the drums under the cupolas. Such "wondrous ornamentation", characteristic of the decor of all 17th century domestic churches, is an inherent feature of the ancient Moscow Kremlin.

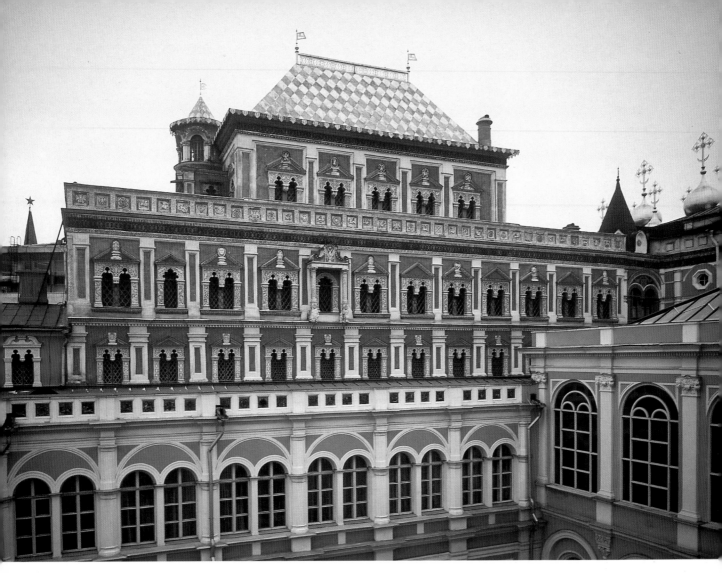

THE TEREM PALACE

The Terem Palace is a true gem of Old Russian architecture in the ensemble of the Grand Kremlin Palace. (The word *terem* means "upper chambers of a palace"). It is a priceless monument of 17th century Russian architecture and social life. This festive-looking palace was built on the orders of Czar Mikhail Feodorovich Romanov in 1635-1636 by a group of master stonemasons headed by Bazhen Ogurtsov. The last occupant of the Terem Palace was Czarevich Alexei Petrovich, the son of Peter the Great.

The architecture and decor of the palace incorporate favorite techniques of Russian "patterned architecture": it seems to be woven with a carved and painted ornamental pattern. The building itself is built of brick and the carved decorative pieces are made of white stone. The master builders made use of every material and form of decor known to them in decorating these "very wondrous chambers". The whitestone portals, cornices and platbands are covered all over with carving, painting, and multicolored tiles made in relief. Their bright glitter harmonizes well with the splendid decor of the building. The double-span windows of the upper

stories with trefoil arches and hanging tie-pieces are crowned with triangular or broken pediments supported by pilasters. Their wide surfaces are filled with braided floral patterns and figures of double-headed eagles and mythical birds and animals.

On top of the main part of the palace is the Gold-Roofed Teremok (Small Terem) with a side turret and a promenade. The stepped silhouette of the building is crowned with a high hip roof. Gleaming with gilt and painting and adorned with an openwork crest, the roof of the Terem Palace could be seen from far away. In the course of the centuries, the palace was altered more than once. During restoration work in the 1960s its original painting was restored.

Before its alteration in the 19th century, the palace's upper Stone Courtyard was an open platform surrounded by a parapet with the Golden Grille that screened off the entrance to the Terem Palace. Three spans of the wrought iron grille have survived to this day. Their exquisite ornamentation in the form of intertwined spirals and fantastic creatures adorned with bright painting and gilt leave you amazed with the variety of the pattern and the richness of the master's fancy. A person walking through the maze of passageways inside the royal palace

some three centuries ago could feast his eyes on a great number of such grilles, forged from iron or cast from copper.

A carved whitestone stairway leads from the Stone Courtyard to the staterooms of the Terem Palace. In olden times, it was known as the *Golden Porch*. The stairway has two landings, a lower and an upper one. The arch of the upper landing is adorned with a decorative tie-piece in the shape of a distinctive-looking lion's head. The banisters and steps of the stairway are decorated with carpetlike gilt whitestone carving and the walls, with multicolored painting. Rearing stone lions guard the entrance to the palace.

The czar's living quarters occupied the third floor of the palace. They consisted of five rooms following one another. Few guests were given the privilege of being received "in the czar's chambers upstairs". The first room of the Terem Palace was called the *Front Hall* or the *Refectory*; here boyars gathered every morning waiting for the czar to appear and occasionally formal meals were held in this room. The second room, known as the Duma or *Council Chamber*, was where the czar held conferences with boyars. The next one in turn, the *Throne Room*, which is the most splendid one among the palace's chambers, served as the czar's study. Its crimson walls are decorated with gilt emblems of the various parts of Russia. Adjoining it is the *Royal Bedchamber* connected with the *Prayer Room*. In the Prayer Room, which is painted all over with images of saints, there are two carved gilt cabinets housing a number of 17th and 18th century icons. Structurally, the design of the chambers was based on that of the Russian four-wall *izba*, peasant log house, with three windows along the façade. The rooms are rather similar in size: all of them are small with low vaulted ceilings. The imposts of the vaults are decorated with bas-relief figures of birds, animals, and double-headed eagles.

The low door recesses of the chambers are decorated with painted and gilded stone carving. In the 17th century, the floors in the rooms were faced in wooden blocks, laid with felt and then covered with green or red broadcloth on top of which carpets were spread on particularly solemn occasions. The windows in the Terem Palace are glazed with colored glass and individual panes have different shapes — squares and triangles — lending the chambers an intimate, fairy-tale atmosphere. The wooden windowsills are covered with exquisitely patterned carving.

If you take a close look at the façade of the palace, you will see that the middle window of the upper story, in the czar's study, is decorated with a particularly attractive whitestone surround. It was called the *Petition Window* for from here a box was lowered into which anyone could put a petition which the czar himself supposedly read and considered. Petitions would lie in wait for a long time and the box came to be known as the Long Box among the common people and gave rise to the saying, "to leave one's business to the Long Box". Tiled stoves were an indispensable component of the chambers' decor. Polychrome tiles of various shapes with patterns made in relief were used in facing them. The patterns of individual tiles relate with one another,

A bird's-eye view of the Terem Palace.

On the next pages: The Front Hall or the Refectory of the Terem Palace.

forming an overall ornamental pattern on the entire surface of the stove. Such tiles usually had a representation of a flower or a rosette in the center and ornamental cartouches or twining stalks along the edges. The stoves seen in the palace today were made in the mid-19th century after ancient models; they reproduce the old patterns faithfully enough, but the colors are largely distorted.

The interior of an Old Russian mansion was rather simple: pillars supporting the vaulted ceiling and wide benches standing along the walls. Chests were usually placed under the benches, which doubled as beds. These simple furnishings were supplemented by a few chairs and *postavtsi* — cupboards for holding tableware. In the royal palaces, however, beds with splendid canopies, carved gilt armchairs and Western-style cupboards began to appear in the early 17th century.

The original wall paintings in the royal chambers have not survived. To a certain extent, one can form an idea

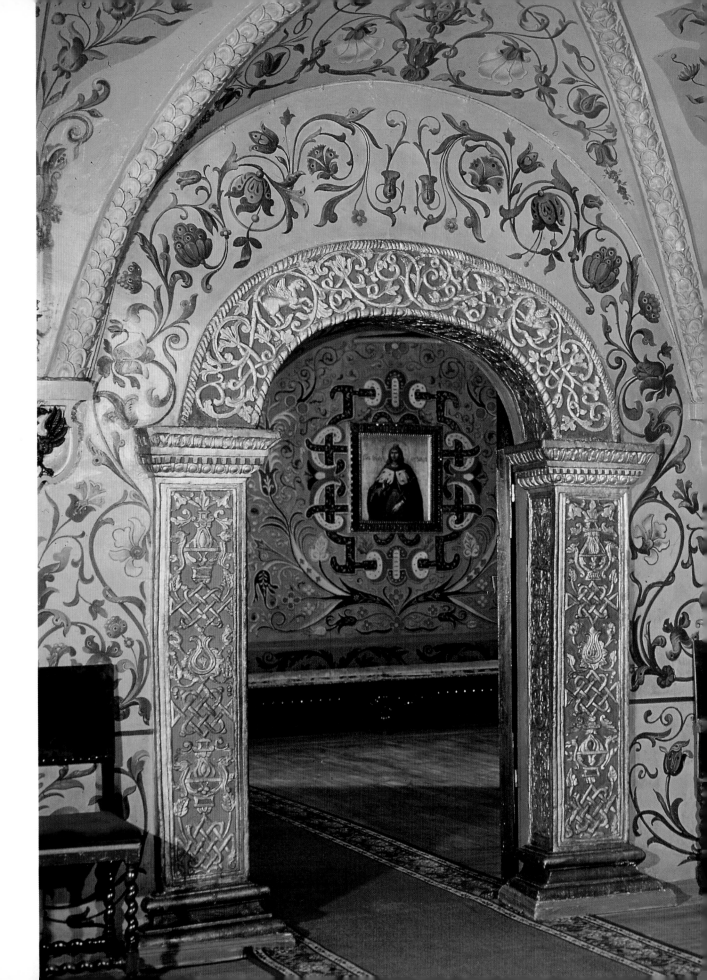

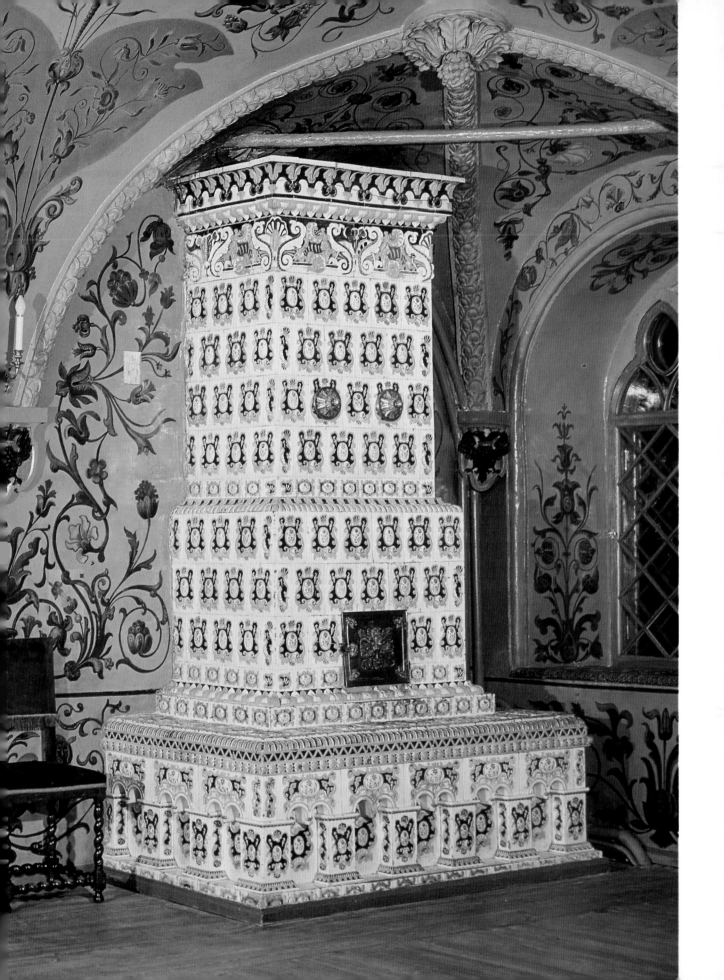

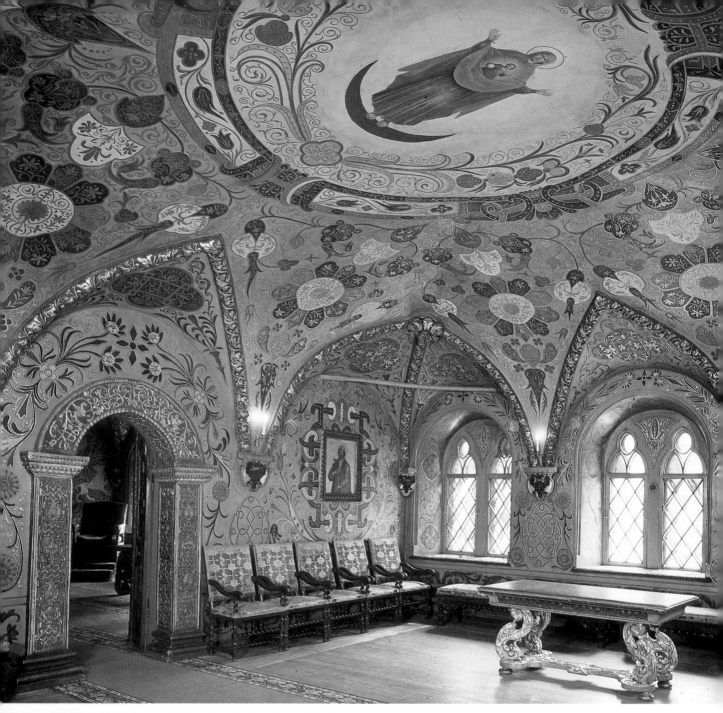

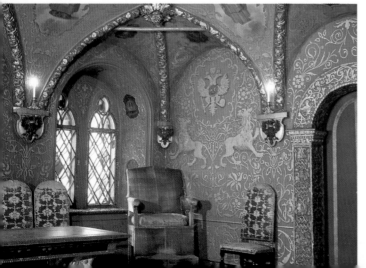

of what the old murals looked like from contemporaries' descriptions and reminiscences that have come down to us: "the wall paintings were distinguished by vivid colors, an abundance of gilt, and fanciful ornamentation". It was the ceilings of the royal chambers that were decorated the most lavishly. The vaulted ceilings were identified with heaven and in decorating them painters aimed to reproduce "all the beauty of heaven". The walls of the chambers were painted with "herbs" and the designs often repeated the floral patterns of Italian and Turkish precious fabrics. Not infrequently, images of saints, which served in place of icons, and *personae* (likenesses) of members of the royal family were also painted on the walls. In the second half of the 17th

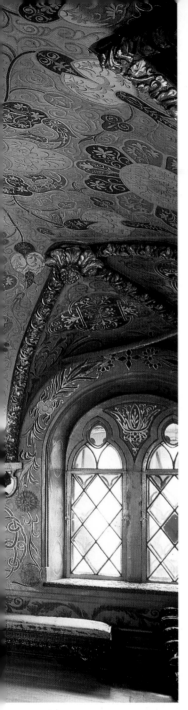

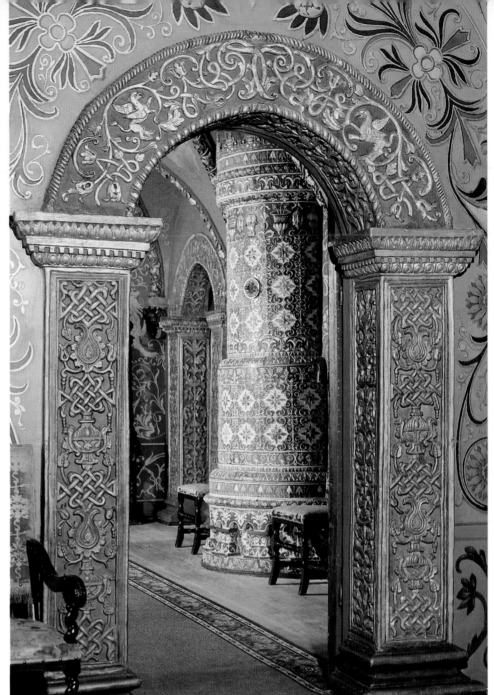

century, subject paintings on Biblical and evangelical themes became widespread.

It is known that the wall paintings in the royal chambers were renovated almost every year and the finest court painters were commissioned to do the job. The wall paintings that have come down to us were executed in the mid-19th century to sketches by Fyodor Solntsev, Academician of Painting.

The royal chambers were adorned particularly lavishly when foreign ambassadors were received. This was done in order to convince foreigners of the power and might of the Russian state and its ruler. On such occasions, the entire way into the palace was laid with Persian rugs and fabrics of various colors, which grew more

The Terem Palace. Top left: the Duma or Council Chamber; right: the portal of the Council Chamber. Bottom: part of the Throne Room.

bright and expensive in the course of time. Hundreds of guards and attendants clad in special precious garments issued from the Treasury stood in lines along the walls of the palace's passageways and stairways.

Despite numerous alterations and additions, the 17th century Terem Palace has largely retained its original ancient appearance. It is a historical and cultural monument in which the exquisite artistic taste of Russian craftsmen and the national character of Old Russian art manifested themselves to a maximum extent.

73

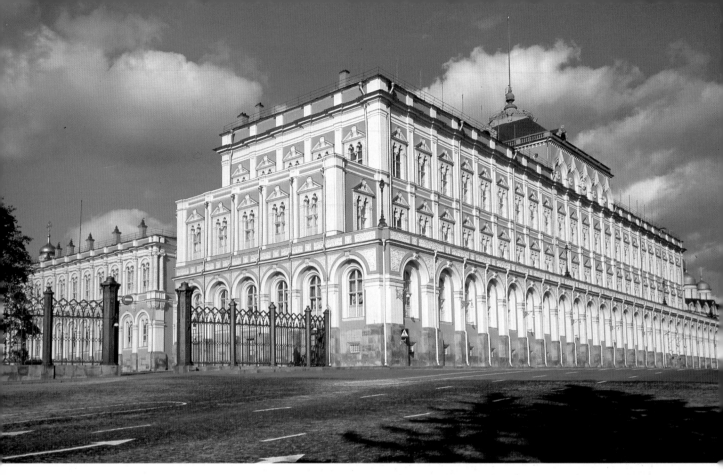

THE GRAND KREMLIN PALACE

The Grand Kremlin Palace. Top: the Georgievsky Hall; bottom: the Vladimirsky Hall.

The ensemble of the Grand Kremlin Palace includes a building dating from the second third of the 19th century — a rare example of Russian national architecture. Its splendid interiors, which have almost completely been preserved to this day, are designed in the spirit of classicism with decorative pieces made in a variety of styles ranging from the baroque to late rococo.

Alongside architects, a number of noted painters and sculptors such as Fyodor Solntsev, Ivan Vitali, Pyotr Klodt, and Alexander Loganovsky were commissioned to decorate the palace's interiors. The ceremonial reception halls — the Georgievsky (St. George) and Vladimirsky (St. Vladimir) Halls and four ceremonial rooms of the so-called Ceremonial Quarters — are situated along the entire perimeter of the first floor of the Grand Kremlin Palace.

The biggest of the palace's ceremonial halls, the *Georgievsky Hall*, with windows arranged in two tiers, was conceived of as a hall commemorating Russian military glory. It is dedicated to the Order of St. George, one of the highest Russian military decorations, instituted by Empress Catherine the Great in 1769.

Every feature of its interior such as its enormous size (the hall is 61 meters long, 20.5 meters wide and 17.5 meters high) and its festive-looking white walls and vaults richly ornamented with stucco molding serve to emphasize the idea of solemn grandeur. Its immense vaulted ceiling is supported by eighteen massive pylons with convoluted zinc columns attached to them. The capitals of the columns are crowned with allegorical statues symbolizing the regions that were incorporated in the Russian state between the late 15th and early 19th centuries (sculptor Ivan Vitali). The marble plaques covering the walls and pylons are engraved in gold with the names of units awarded the insignia of the Order of St. George and of servicemen decorated with the Order of St. George or a full set of St. George's Crosses. Included in the stucco molding of the walls and vaults are representations of the insignia (the star and the cross) of the Order of St. George and on the semicircular uppermost parts of the end walls equestrian statues of St. George in high relief by the sculptor Pyotr Klodt are to be seen. The superb parquet of twenty valuable varieties of different colored wood was made to the design of the painter Fyodor Solntsev. Today ceremonial functions and diplomatic receptions are held in this hall.

Next to the Georgievsky Hall is the *Vladimirsky Hall* built in 1838-1849 on the site of the 17th century open-air Boyar Square of the Terem Palace. Today it links the 15th-17th century palatial buildings with those built in the 19th century. The hall is dedicated to the Order of St. Vladimir instituted by Catherine the Great in 1782. Shaped like a square with cutoff corners in

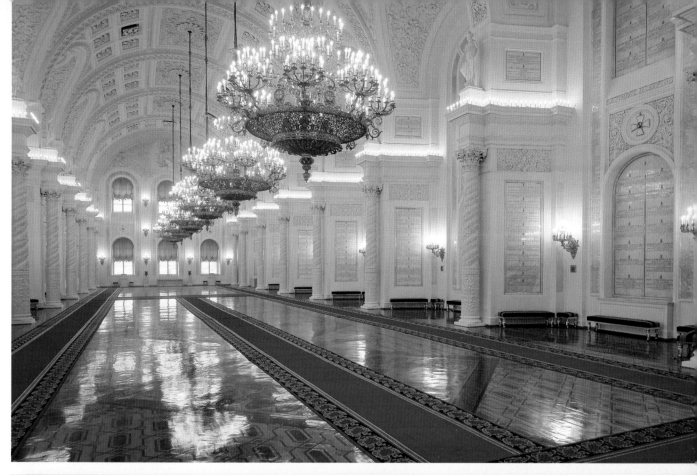

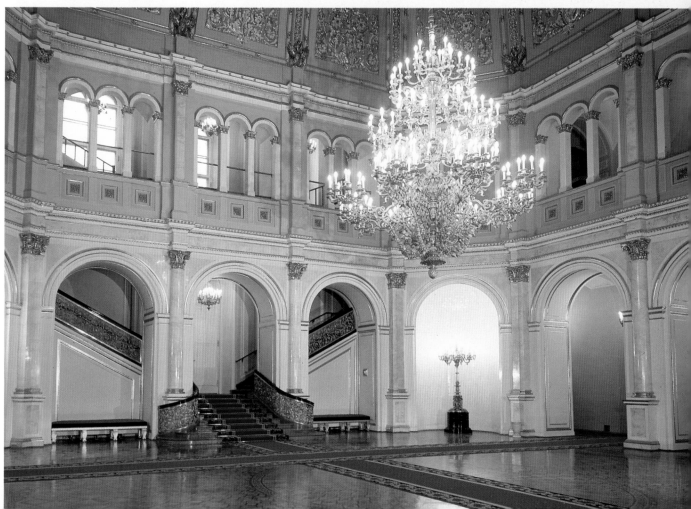

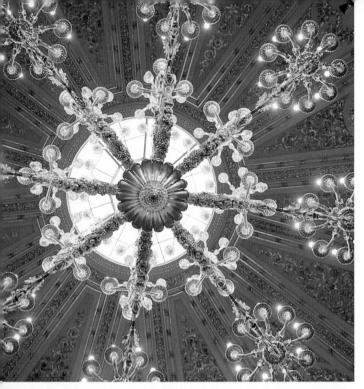

plan, it consists of large wide arches in the lower part on top of which are smaller arches with galleries behind them. The walls and pilasters of the hall are faced with pink artificial marble. It is topped with a domelike vault ornamented with a gilt pattern and representations of the insignia of the Order of St. Vladimir — a gold cross with red enamel and a star. In the daytime, sunlight flows in through the glass walls of the dome. Hanging from the skylight on top of the dome is a large bronze chandelier. The floor in the hall is decorated with parquet made of rare sorts of wood to sketches by the painter Fyodor Solntsev. The gilt benches standing near the walls are upholstered with moire in the colors of the St. Vladimir Order ribbon.

The first floor of the Grand Kremlin Palace on its western side is occupied by an enfilade of the Ceremonial Quarters rooms — the Yekaterininsky (St. Catherine) Hall, the Ceremonial Drawing Room, the Royal Bedchamber, and the Walnut Dressing Room.

The *Yekaterininsky Hall*, formerly the throne room of the Russian empresses, was named after the Order of St. Catherine, the only order for women in Russia, instituted by Peter the Great in 1714. The order was awarded to ladies of the court for their support of charities.

The cross vault of the hall is supported by two massive pylons with pilasters on marble socles, crowned by bronze capitals and faced with a beautiful malachite mosaic. The walls are hung with gray moire bordered with red (the color of the St. Catherine Order ribbon) and ornamented on top with decorative insignia of the order against the background of the order's red ribbon bearing its motto: *For Love and Motherland*. Gilded stucco molding on the vaults and cornices, skillfully executed carved doors covered with gilt and adorned with representations of the order's insignia, gilded bronze chandeliers and six strikingly beautiful crystal girandoles on stands of French red marble made at the imperial glassworks in St. Petersburg lend the hall a particularly festive look. The parquet floor in this hall, made of carefully selected varieties of fine wood and noted for its superb pattern, is also of great artistic value.

The next one after the light silver-gray Yekaterininsky Hall is the *Ceremonial Drawing Room* designed in the Renaissance style. The vaulted ceiling of this semicircular hall was ornamented with a flowered pattern by painter D. Artari.

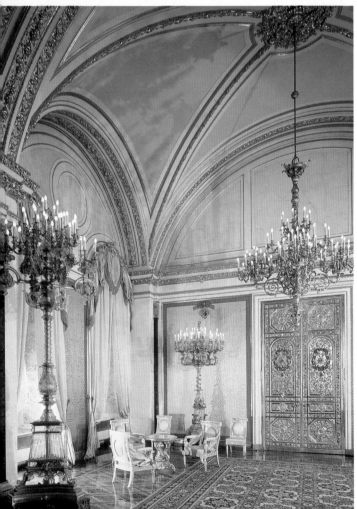

The Grand Kremlin Palace. Top: a detail of the dome of the Vladimirsky Hall; bottom: the Yekaterininsky Hall; opposite: the entrance to the Yekaterininsky Hall.

On the next pages: left: the Grand Bedroom; right: the Grand Drawing Room.

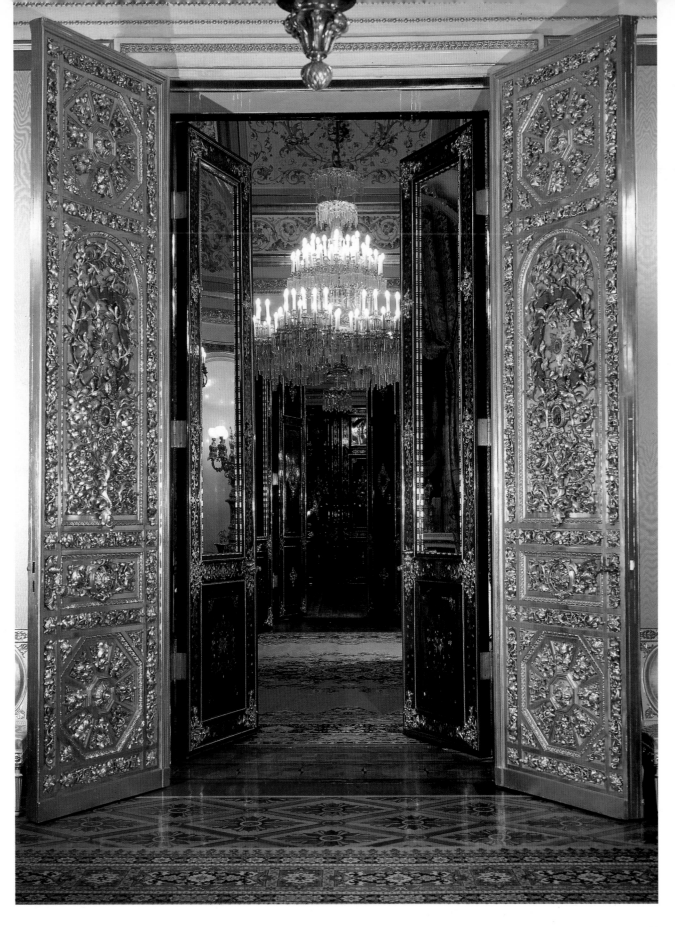

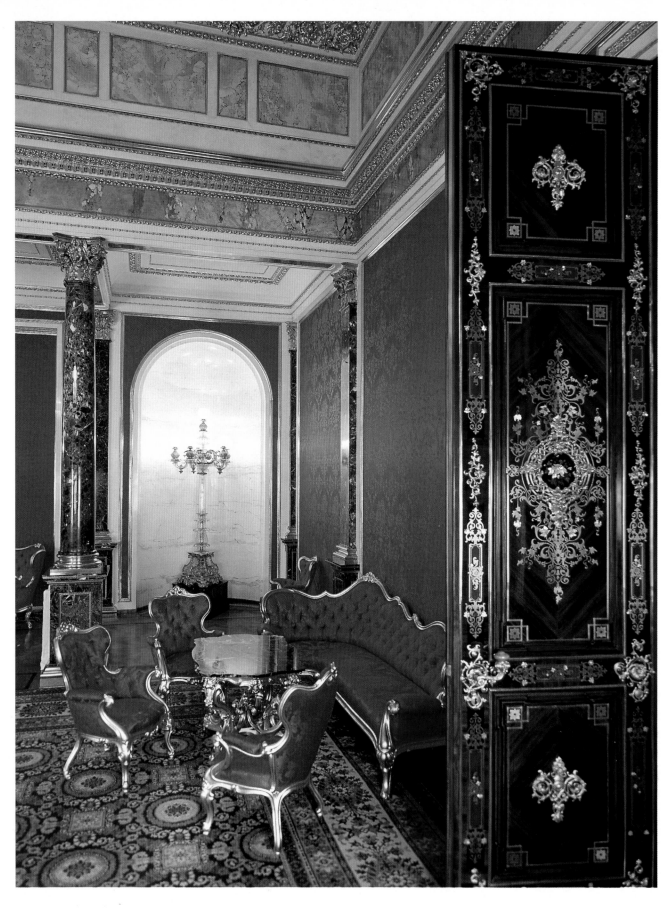

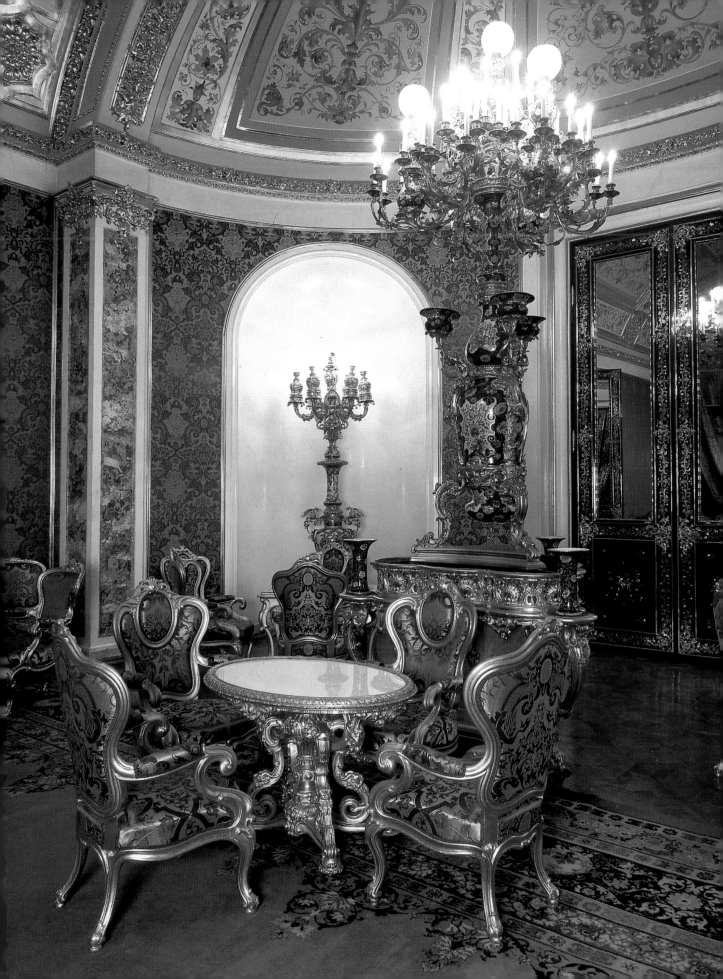

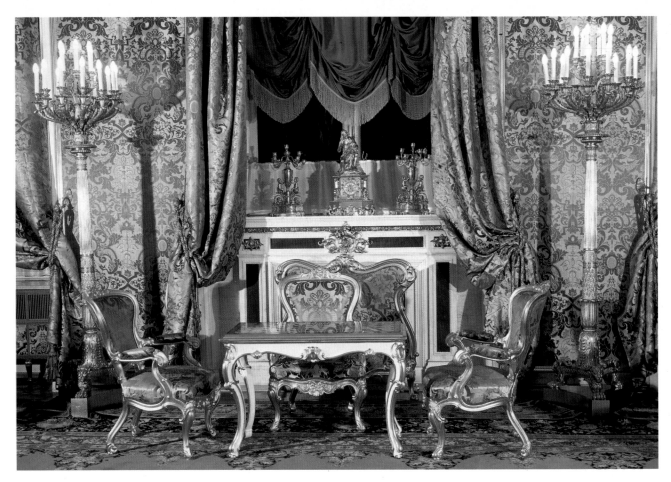

*The Grand Kremlin Palace. A corner
of the Grand Drawing Room.*

*The Grand Kremlin Palace. The White Dining Room
and the Empress's Boudoir. The malachite mantel.*

On the ground floor of the palace are the *Private Chambers* — the imperial family's private apartments — forming a straight enfilade with windows looking south. In decorating the interiors of the rooms, decorative pieces of various styles such as classicism, the baroque and rococo were used. Massive pylons divide the rooms into cozy nooks. Skillfully arranged period furniture, richly ornamented with inlaid work, harmonizes well with the space of the rooms, creating an atmosphere of comfort and intimacy. Each of the seven rooms — the Dining Room, the Drawing Room, the Empress's Study, the Boudoir, the Bedroom, the Emperor's Study, the Reception Room — and four small rooms serving as passageways are unique examples of 19th century interior decoration.

The enfilade of the Private Chambers opens with the *Dining Room,* the biggest and lightest of them. Its decor features the decorative principles of classicism; in particular, its walls and ceiling are faced with artificial light marble. The piers and niches are adorned with the marble sculptural groups *Leda and the Swan* and *Hymen.*

The *Dining Room* is lighted by crystal chandeliers. It should be noted that the chandeliers in each of the

palace's rooms are absolutely original, each with its own variety of pendants, and emphasize the magnificence of the interiors. Each room is ornamented with exquisite gilded stucco molding on the vaulted ceilings and on the capitals of pilasters and columns, which makes them look particularly festive. The unique color of the interiors is achieved by using splendid damask of different colors as wall hangings and window draperies. The impression of splendor is further enhanced by furniture and doors richly inlaid with bronze and tortoise shell and marble mantels with clocks and candelabra placed upon them. The main adornment of the *Drawing Room* is its porcelain chandelier made to look like a rich bouquet crowned with a pineapple. The Russian craftsmen working at the Imperial Porcelain Factory in St. Petersburg were famous for their art of making porcelain flowers.

Great mirrors, buhl furniture and dark-crimson damask wall hangings lend the *Empress's Study* an imposing appearance fully corresponding to the aesthetic principles and ideals of those times.

The main attraction of the *Boudoir* is its splendid mantel faced with pieces of green Ural malachite matched in pattern and color so skillfully that it seems to be made from a monolith. The mantel is ornamented with gilt

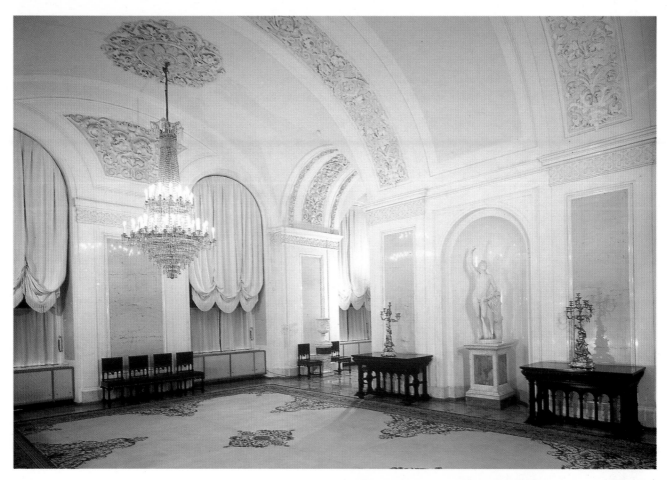

laid-on pieces in the form of bronze sirens, cartouches, rosettes, and floral patterns. The 19th century craftsmen working at the Demidov and Turchaninovs factories in the Urals were noted for their great skill in cutting and dressing malachite.

The more austere decorative scheme of the rooms that follow the Boudoir — the *Bedroom* and the *Emperor's Study* — is fully in keeping with their functional purpose. The walls and modest furniture of the Bedroom are covered with blue moire. The ceiling is exquisitely painted with bouquets and intricate floral patterns. The room has a beautiful mantel of white marble with a traditional mantel clock and candelabra on the shelf.

The Emperor's Study is faced with light ash and its furniture is upholstered with green leather. The pier between the windows is adorned with a mantel and a large mirror above it. The ceiling is ornamented with stucco molding and a chandelier in the Art Nouveau style.

On the next pages: left: the Empress's Study;
right: the enfilade of living rooms.

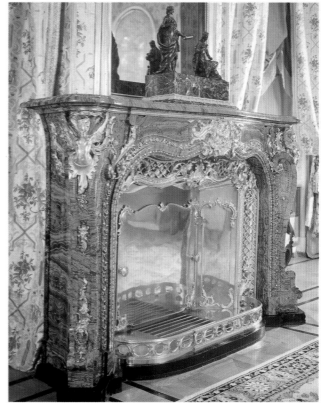

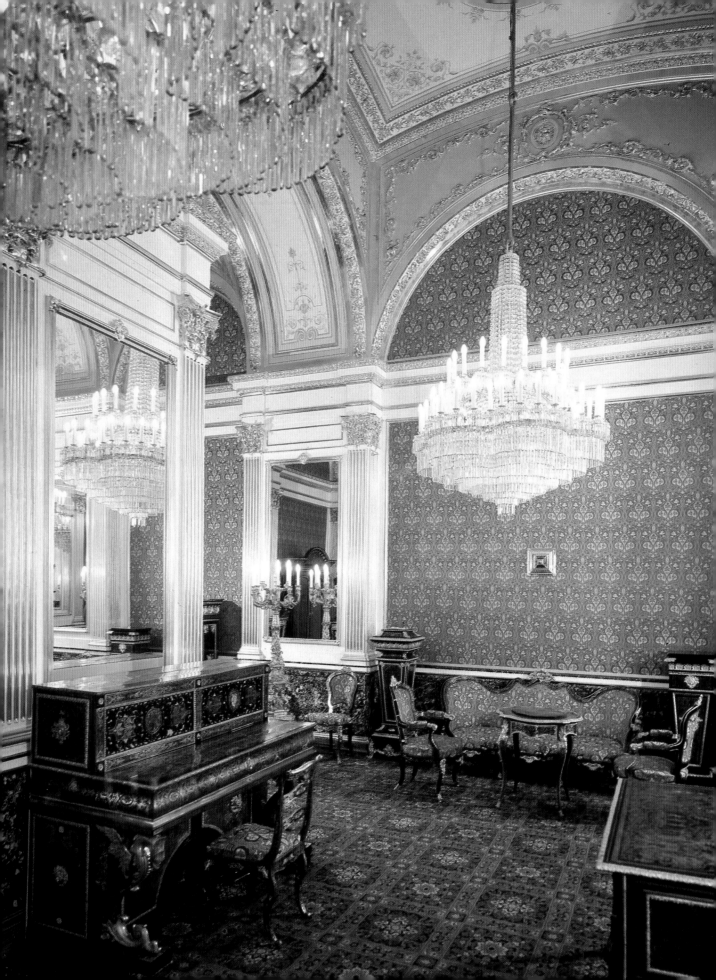

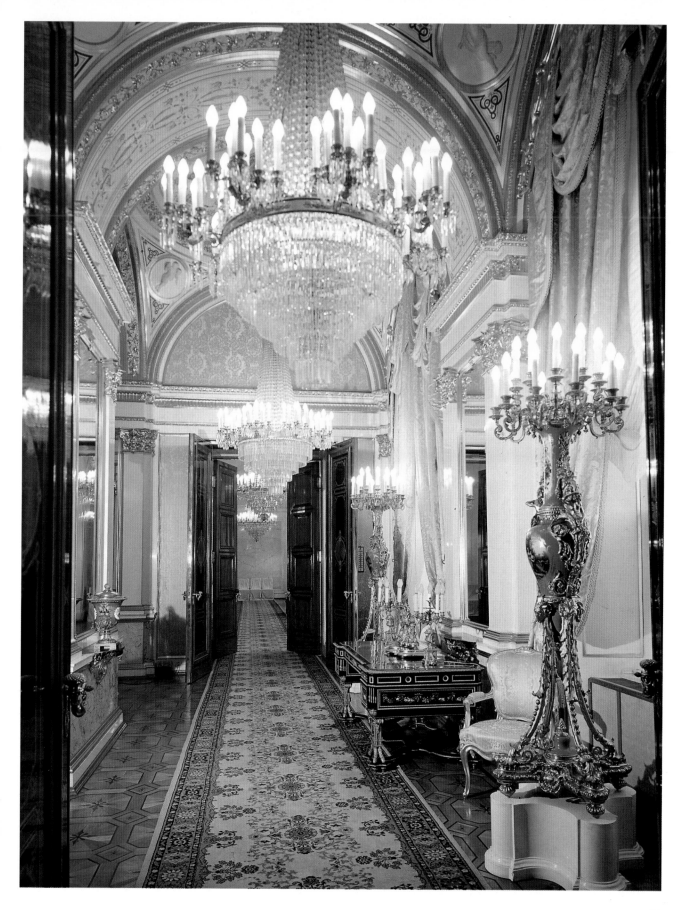

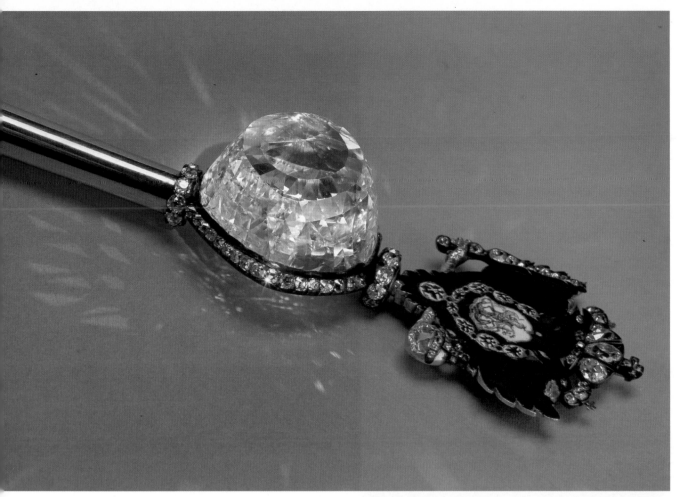

The Diamond Fund Exhibition. Top: the Orlov diamond; bottom: grand brooch. Mid-19th century.

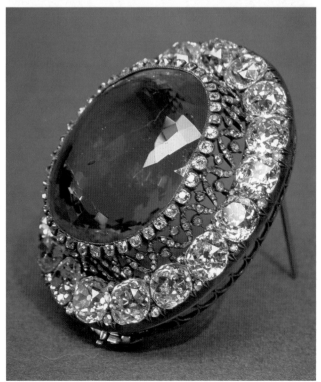

hemispheres divided by a lush floral garland and held together by a narrow circular band. The cold glitter of the 5,000 diamonds adorning the crown is offset by the dim gleam of beautiful large pearls. The crown is topped with one of the Diamond Fund's seven historic gems — a 398.72 carat noble spinel brought to Russia by Nikolai Spafary, who was the Russian ambassador to China in 1675-1678.

The orb and scepter are rather austere in design. The gold orb, made in 1762, is a small polished globe with a cross on top, crisscrossed with two bands adorned with large diamonds.

The *Orlov* diamond, another one of the Diamond Fund's historic gems, has adorned the austere-looking scepter since 1774. This diamond, the world's fourth in size (it weighs 189.62 carats), was found in India.

The Lesser Diamond Crown was made by the Duval brothers, the jewelers, to be worn by Elizabeth Alexeyevna, the wife of Emperor Alexander I, during his coronation in 1801.

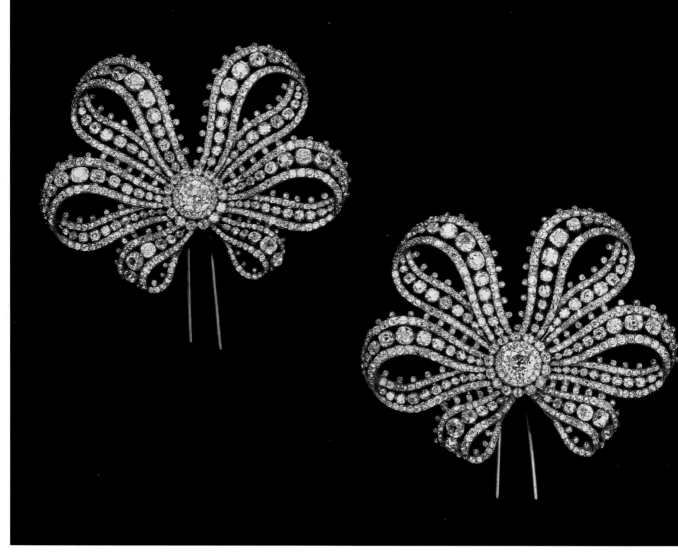

*The Diamond Fund Exhibition. Diamond hairpins.
Mid-18th century.*

*The Diamond Fund Exhibition. The star of the Order
of St. Andrew the First-Called. 1805-1815.*

The state regalia are adorned with two unique gems.
They are unparalleled in their size and color charac-
teristics. There are many legends and traditions associated
with these gems.

The 25 carat flat *Tafelstein* (Table Stone) diamond
adorned a portrait of Emperor Alexander I. Diamonds
of this type are extremely rare.

The historic gems include the *Shah* diamond, weighing
88.7 carats, which has been preserved in its natural
form. Found in India in the 16th century, it was regarded
as a talisman. Three of its sides have inscriptions in
Persian with the names of the diamond's owners, which
help to unravel its fascinating history. In 1829, the gem
was presented by an embassy of Crown Prince Khozrev
Mirza of Persia to Emperor Nicholas I "in atonement
for the murder of the white ambassador", as the Persian
newspapers wrote at the time, meaning Alexander Gri-
boyedov, the outstanding Russian author and diplomat
who had been assassinated in Teheran.

Two unique gems — a 258.8 carat Ceylon sapphire
and an enormous Colombian emerald weighing 136.25
carats — adorn the diamond brooches of the first half
of the 19th century on display at the exhibition.

Still another one of the seven historic gems is a
greenish-olive chrysolite weighing 192.6 carats. The
stone was found on volcanic Zaberget Island in the
Red Sea.

An important part of the display at the Diamond Fund
Exhibition is a collection of decorations studded with
jewels. These exhibits include the diamond chain and
star of the *Order of St. Andrew the First-Called*, the
first order to be instituted in Russia, and the insignia
of the Orders of St. Catherine and St. Alexander Nevsky
and of the foreign Order of the Golden Fleece.

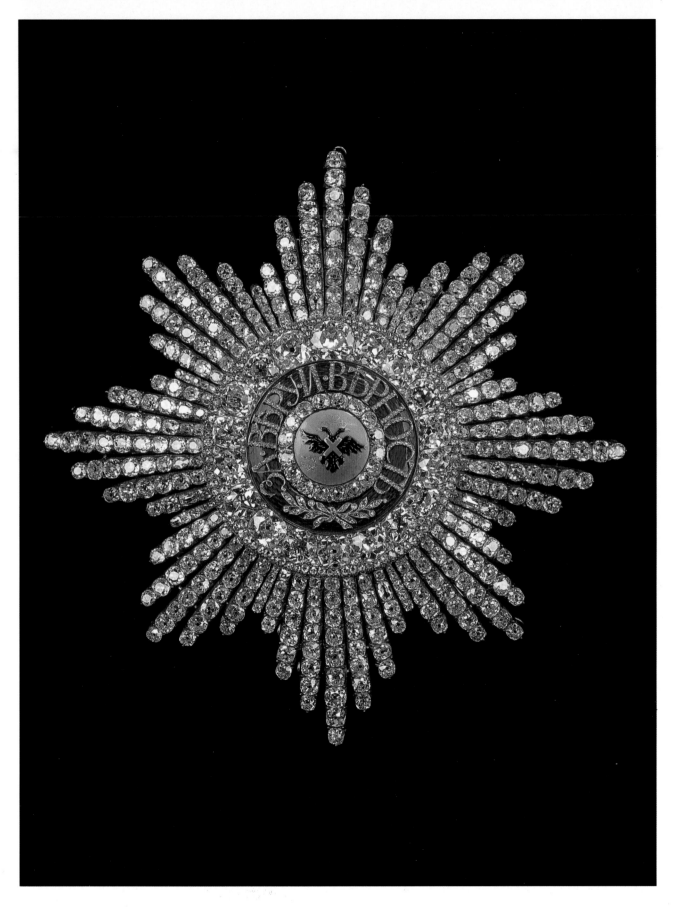

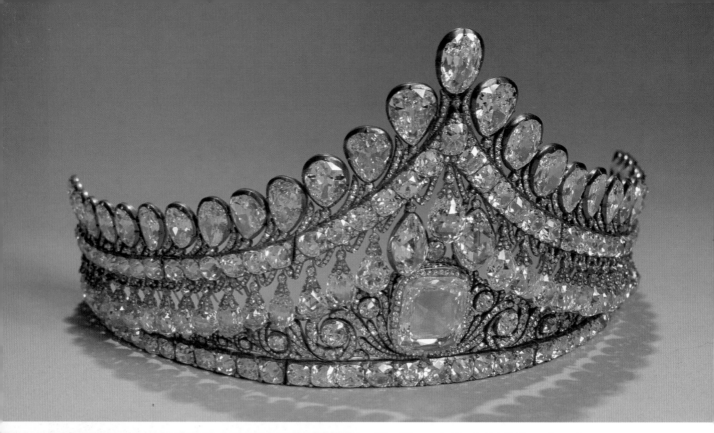

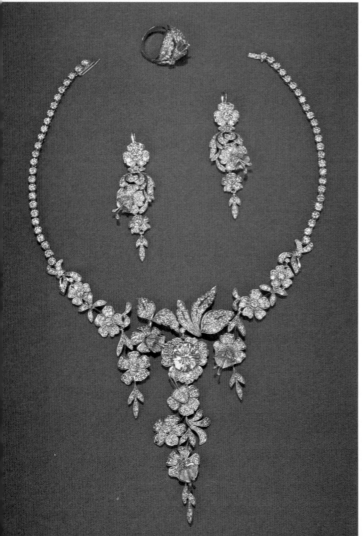

The Diamond Fund Exhibition. Opposite: the "Grand Bouquet". C. 1760. On this page: top: a diadem. C. 1810; bottom: a necklace, earrings and a ring. 20th century.

Visitors are attracted to the sections displaying diamonds found at various deposits in Russia, a collection of cut diamonds, and an absolutely unique collection of "named" giant diamonds ranging in weight from 20 carats to a maximum of 342.57 carats — such is the weight of the biggest diamond found in Yakutia in 1980.

The Diamond Fund Exhibition also features works by today's leading master jewelers, continuing the finest traditions of the centuries past. The exquisite, lacy *Rose* brooch that seems to be woven from 1,500 diamonds, the splendid *Russian Beauty* diadem, the *Russian Field*, an article epitomizing Russia's natural scenery, and also a number of articles adorned with emeralds and amethysts, and pearl necklaces are a unique blend of technical skill and artistic inspiration.

The display concludes with a unique collection of precious nuggets — 20 platinum and 100 gold nuggets — from a number of deposits in various parts of Russia. The biggest platinum nugget weighs 7.8 kg and the biggest gold nugget, found in the Urals in 1842, weighs 36 kg.

Visitors to the exhibition are invariably impressed by the talent of the master jewelers, the beauty of the articles they made and the great cultural heritage handed down to us by our ancestors generation after generation.

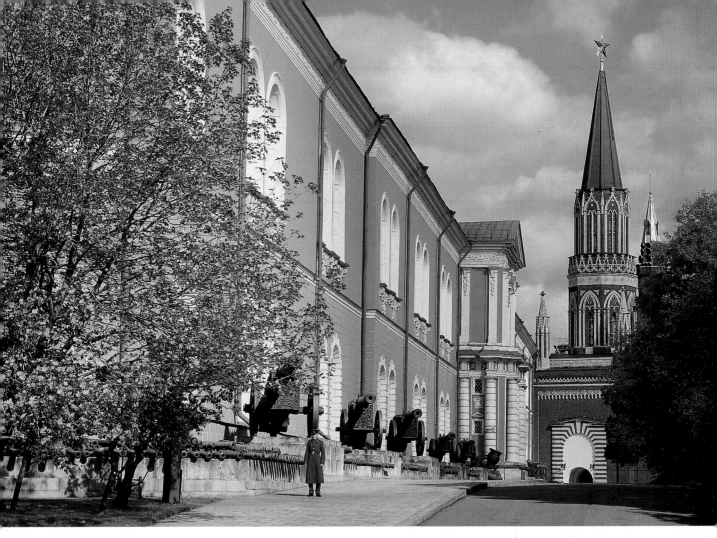

A detail of the Arsenal building.

INSIDE THE ANCIENT KREMLIN WALLS

THE POTESHNY PALACE

The Poteshny Palace, a major monument of 17th-century Russian civil architecture, situated near the Kremlin wall between the Komendantskaya (Commandant's) and the Troitskaya (Trinity) Towers, was built in 1652 as Boyar Miloslavsky's chambers. In 1672, by order of Czar Alexei Mikhailovich, it was rebuilt and began to be used as a place of amusement for the royal family. It was then that it became known as the Poteshny (Amusement) Palace. It was here at the Poteshny Palace that domestic performances, which marked the beginning of the Russian court theater, were staged for the first time in Russia. In the course of its repairs in the last quarter of the 19th century, the appearance of the structure was changed considerably: a whitestone portal with carved ornamentation was added to its main façade and a balcony supported by bottle-shaped posts was built on its opposite side. The upper tier of the palace forms a *terem* (towerlike upper structure), which at one

time housed a palace church. Nowadays, the earlier alterations notwithstanding, the outward appearance of the palace has preserved its inimitable national character.

THE ARSENAL

The building of the Arsenal is situated between the Troitskaya, Nikolskaya and the two Arsenal Towers. The long and arduous history of its construction began in 1702. Its general layout was conceived by Peter the Great himself. Architects M. Choglokov, M. Remezov, D. Ivanov, and Ch. Konrad were commissioned to erect the building. Its construction, however, dragged on for several decades. In 1706, the work was discontinued because of the war with Sweden and not resumed until 1722. The building was completed in 1736. This date is carved in the surround of the building's gate.
A year later, however, the Arsenal was severely damaged during a great fire in the Kremlin. In 1786-1796, it

was restored by engineer L. I. Gerard under the supervision of the architect Matvei Kazakov. In 1812, the building was once again damaged — this time, by a blowup during the retreat of Napoleon's troops from Moscow. Its restoration was finally completed in 1828. The 24-meter high building of the Arsenal, trapeziform in plan, with a large courtyard and two gateway arches, is built of brick and decorated with whitestone.

Initially, the Arsenal was used for storing weapons and military equipment. It was also planned to bring the most valuable war trophies here. Later on, it was decided to establish a museum of the 1812 Patriotic War in the building of the Arsenal. Along its southeastern façade are 749 cannons — mostly those captured by the Russian troops and partisans during the retreat of Napoleon's Grande Armée in 1812. Their bronze barrels were cast in Paris, Lyons, Breslau, and other European cities in 1790-1810. Of particular value are twenty 16th and 17th century Russian cannons made by outstanding Russian craftsmen Andrei Chokhov, Martyn Osipov and Yakov Dubinin.

On the southern façade of the Arsenal near the entrance arch there is a memorial plaque commemorating the Arsenal soldiers shot down by cadets during the revolt in October 1917. In 1965, another memorial plaque dedicated to the officers and men of the Kremlin garrison who died defending Moscow and the Moscow Kremlin against Nazi air raids during the Great Patriotic War of 1941-1945 was put up near this arch.

In 1970-1977, extensive restoration work was carried out at the Arsenal: its façades were renovated, its structural members and foundation were strengthened, a number of details of its decor were restored, and its metal gates were repaired. The Russian and French cannons placed along its façade were also restored; in particular, the ornamentation, coats of arms and inscriptions adorning their surface were cleared up.

THE SENATE

Another fine example of 18th century architecture among the Kremlin structures is the building of the Senate. Its construction lasted from 1776 to 1788 and its interior decoration was completed only in 1790. The design of the building was made by Matvei Kazakov, the noted Russian architect.

The building was initially intended as the place where the nobility of the Moscow Gubernia (Province) would meet. After two of the Senate's departments were transferred from St. Petersburg to Moscow, however, it was made into the Moscow Senate.

The three-storied vaulted brick building of the Senate is built in the style of early Russian classicism.

The architect, Matvei Kazakov, brilliantly coped with the task of designing its layout: the building, which is triangular in plan, has three inner courtyards. Its focal point is the majestic rotunda of the domed hall. Originally, the dome was crowned with an equestrian statue of St. George the Victorious, the emblem of Moscow, which was replaced with a representation of Justice after the Judiciary Office was housed in the building in 1856.

The Round Hall of the Senate is by right regarded as an architectural masterpiece. It is surrounded with columns and pilasters of the Corinthian order and a narrow gallery above which rises a 27-meter high groined dome 24.7 meters in diameter. In the piers between the windows there are bas-relief portraits of Russian czars and grand dukes, and also plaster casts of the marble originals by Fedot Shubin now adorning the halls of the Armory. In the gaps between the columns there are 18 bas-relief panels by sculptor G. T. Zamarayev, featuring allegorical subjects. The interior of the Oval Hall, more moderate in decoration, is no less elegant. In 1918, when the capital of Soviet Russia was transferred from Petrograd to Moscow, the Soviet government was housed in the building of the Senate and the red flag was raised above the huge dome. Today the tricolor flag of Russia flies above it.

THE STATE KREMLIN PALACE

This is an architectural monument of our times in the Moscow Kremlin. Built in 1960-1961 next to the Troitskaya Tower, it is the biggest public building in Moscow. The ex-palace of Congresses was built on the site of several 19th-century service buildings and the old building of the Armory (1806-1810).

In order to inscribe a modern building in the ancient ensemble of the Kremlin, the palace was sunk 15 to 16 meters into the ground, thanks to which it does not seem too prominent among the older structures surrounding it. The main façade of the palace faces the Arsenal, on its southeastern side it is connected by passageways with the Grand Kremlin Palace and a small Winter Garden, and on its northern side the palace overlooks former Palace Street with the 17th-century Poteshny Palace. The palace, faced with white marble, is rectangular in plan. Its polished glass walls, reflecting the Kremlin's ancient architectural monument, look very picturesque. The palace contains 800 rooms of different size. On entering the palace, the visitor gets into a light and spacious foyer ornamented with a decorative frieze of multicolored gilt smaltos. The mosaics are made after drawings by Alexander Deineka, the noted artist famous for his works of monumental art.

The palace's main hall is its auditorium seating 6,000. The red and gold colors of the auditorium and the corrugated wooden panels covering its walls lend it a solemn appearance. As regards its size and technical equipment, it is one of the biggest and best-equipped auditoriums in the world. All the seats are fitted out with special electronic units which are part of a system of simultaneous translation into 30 languages. The auditorium has excellent acoustics and the nearly 5,000 electric lighting fixtures built into its ceiling provide for a varied choice of overhead illumination schemes. The auditorium's stage is one of the world's biggest theatrical stages equipped with a modern system of hoists allowing various scenic transformations to take place.

Above the auditorium there is a banquet hall for 2,500 people. Various formal functions are held here. With its transformable terraced floor, the banquet hall can be easily adjusted to suit the needs of any particular function.

The palace is a multipurpose public building. International congresses, meetings and conferences, as well as stage performances are regularly held in it.

RED SQUARE

Both territorially and historically, the Moscow Kremlin is inseparably linked with Red Square, the main square of the Russian capital. The monuments situated in Red Square, however, are not part of the Moscow Kremlin Reserve.

Today Red Square is not only Moscow's main historical and architectural attraction, but also its grand forum and a witness to major historical events in the life of the country.

The architectural ensemble of Red Square is one of the best-known in the history of urban development in Russia and its finest gem is the Cathedral of the Intercession on the Moat.

The **Cathedral of the Intercession**, popularly known as the **Cathedral of St. Basil the Blessed**, was built in 1555-1561 in commemoration of the victory over the Kazan Khanate and, in fact, as a monument epitomizing the triumph of completing the long way of Russia's liberation from the foreign yoke. It is significant that the cathedral was built not inside the Kremlin walls but between the Kremlin and the *posad* (merchants' and artisans' settlement) as an embodiment of an event of nationwide importance.

History has preserved the names of the master builders, Barma and Postnik, by whose genius this architectural masterpiece was created (some scholars believe that they were, in fact, one person, Postnik Barma). According to one of the legends, Czar Ivan the Terrible ordered the master builders to be blinded so that there would never be anything more beautiful in the world than the Cathedral of the Protecting Veil. The czar wanted the master builders to erect a cathedral consisting of a cluster of eight hip-roofed pillarlike churches each of which would be dedicated to the holy days and saints whose feast days coincided with the dates of major victories won by Moscow in the war with the Kazan Khanate. Barma and Postnik, however, dared to go against the czar's will in implementing their artistic idea, which undoubtedly required no small courage on their part. They decided to build nine churches, which enabled them to create a symmetrical, well-balanced

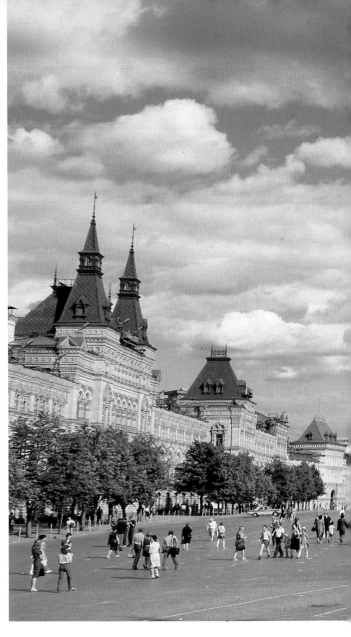

Three views of Red Square.

122

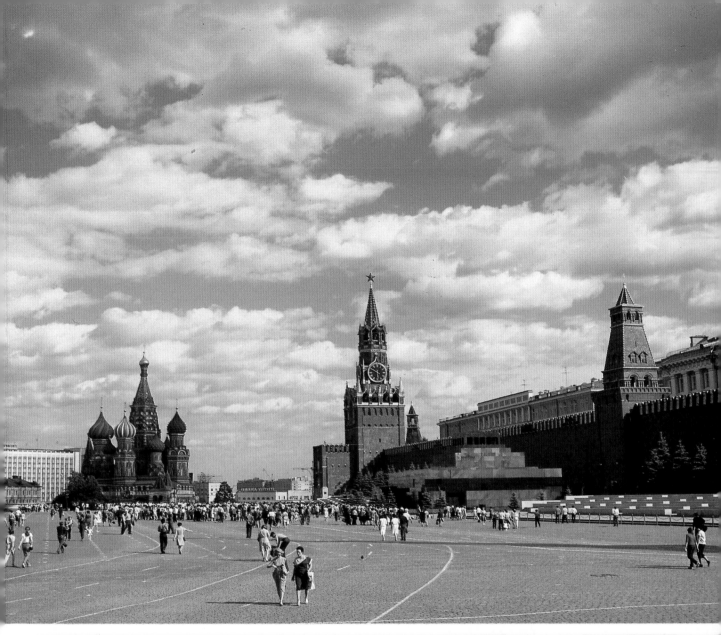
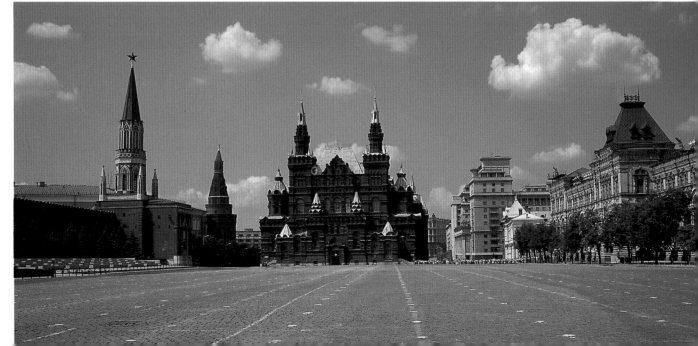

composition that affords an unhindered view of the cathedral from every side. Each of its nine towers are quite unlike the others in size and architectural decor whose salient feature is numerous tiers of *kokoshniki* arches.

Apparently, the rare perfection of the cathedral's architectural forms was achieved without preliminary validation of its dimensions. As is known, N. N. Sobolev, the restorer architect, noted the presence of a wooden framework inside its brick walls. Evidently, many of the cathedral's decorative elements were made right here on the spot. The Cathedral of St. Basil the Blessed is absolutely unparalleled in grandeur, artistic perfection and workmanship.

The square that emerged on the territory of the Great Trading settlement is known as Krasnaya, which in olden days meant "beautiful" but now means "red". Other Russian cities also had similar squares. This name affirmed its role as the main public square in the life of the city for centuries to come. Unlike the Kremlin's Cathedral Square, which was the site of official ceremonies, Red Square was, in effect, a marketplace.

Interesting information was obtained during archaeological excavations carried out in 1988 in Istorichesky Passage leading to Red Square. It transpired that, following the construction of the present Kremlin walls and towers by Ivan III, this area was covered with stone paving on top of the remains of 12th-14th century wooden *posad* structures. It was also here that an inscription on birch bark, the first one to have been found in Moscow, was discovered. In surveying the earth filling what once was the Alevizov (Alevisio's) Moat, the Kremlin archaeologists found various ceramic articles in the form of whistles and simple wind instruments, which confirms the fact that Red Square used to be the venue of popular outdoor entertainments. Red Square was from the very beginning situated outside the citadel, which, however, always gave it reliable protection, and it served as a kind of a grand entrance to the Kremlin.

At the turn of the 18th century, the entrance to the square through the Voskresenskiye (Resurrection) Gates near the Cathedral of the Kazan Icon of the Mother of God took shape. After the great fire and the retreat of Napoleon's troops from Moscow in 1812, Red Square was cleared of various structures of minor importance and a view of the Kremlin was opened up.

In the 1820s, the trading rows along the Alevizov Moat were pulled down, the moat itself was filled in, and a lime-tree alley was laid out at the foot of the Kremlin wall. The boulevard situated here was named Vassilyevsky Slope.

In 1818, a *monument to Kuzma Minin and Prince Dmitry Pozharsky*, the heroes of the 1612 war of liberation (sculptor Ivan Martos), was put up in front of the central portico of the Upper Trading Arcade rebuilt to the design of the architect Osip Beauvais.

On the northern side of the regular rectangle which is the form of Red Square today towers the majestic building of the State History Museum built by architects V. O. Sherwood and A. A. Semyonov in 1878-1883. On the eastern side of the square stand the shopping arcades of the GUM (State Department Store), formerly known as the Upper Trading Arcade, built in 1895 to the design of architect A. N. Pomerantsev.

In this way history itself has shaped up the architectural and town-planning features of Moscow's main square. In Red Square by the Kremlin wall is the necropolis where heroes of the revolution and the Civil War, as well as noted political and public figures and prominent military leaders lie buried.

In 1930, the Lenin Mausoleum, a classical monument of the period, where lies the body of Vladimir Lenin, was built here of red and black granite. On June 24, 1945, during the historic Victory Parade, the standards of defeated Nazism were cast at the foot of the Mausoleum.

Today, as before, Red Square remains the focal point of the great city of Moscow.

In 1990, Moscow's historical nucleus — the Kremlin, Red Square and the Alexandrovsky Gardens — was included in the World Heritage List of UNESCO signed by 120 states of the world, which was an act of international recognition of its world significance.

Monument to Kuzma Minin and Prince Dmitry Pozharsky, the heroes of the 1612 war of liberation. 1818. Sculptor Ivan Martos.

The Cathedral of the Intercession (Cathedral of St. Basil the Blessed). 1555-1561.

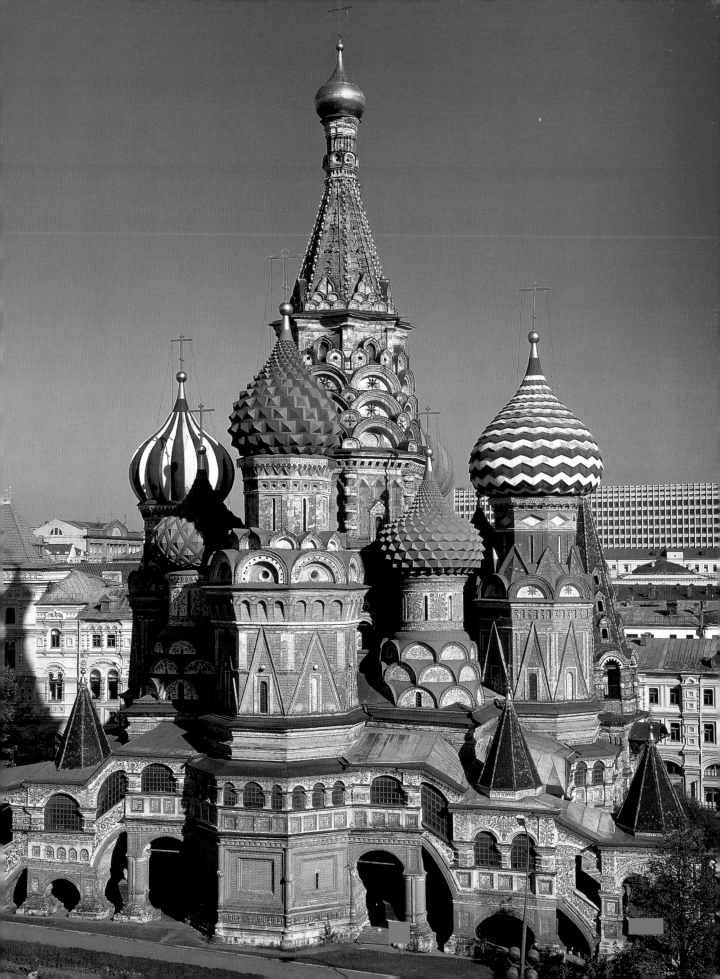

Sliding Table

Illus. 1-16. *A sliding or rolling table is built into some table saws. A rolling table makes it safer and easier to handle large pieces.*

Illus. 1-17. *This Mule™ sliding table is an accessory that can be attached to most contractor or cabinet saws. It enables the operator to handle larger pieces of stock safely and with less effort.*

Sliding tables have stops or travel limits at both ends which keep the table from sliding out of its track. Most of these tables also have provisions for adjustment. Woodworkers who handle large pieces of panel stock favor sliding tables because they make it much easier to handle.

Some companies offer a sliding table as an add-on accessory for their table saw. (See Illus. 1-17.) These sliding tables do the same thing as the sliding table that comes with the table saw, but may take up more floor space.

Add-on sliding tables can be purchased to fit almost any table saw. They allow a single operator to handle larger stock. Be sure that the add-on table is compatible with the saw before you buy it.

Many woodworkers believe that a rolling table should be able to crosscut a piece 48 inches wide.

This type of rolling table takes up a great deal of shop space. A smaller rolling table is adequate for most shops, since most rip cuts are made first. Rolling tables which accommodate stock 24 inches wide will usually suffice for most shops.

Determining Table-Saw Size

The size of a table saw is measured in many ways, including overall size, table size, and blade diameter. The following examination of these different types of measurement will help you determine what ones are important to your work.

Blade Diameter

Blade diameter is the most common method of determining table-saw size. The largest diameter blade that the table saw will take determines its size. (See Illus. 1-18.) For example, a table saw that will take a blade with a 10-inch diameter is a 10-inch table saw. The diameter of the blade affects the maximum thickness of stock that the table saw will cut.

Illus. 1-18. *One way of determining saw size is by the largest blade diameter that the saw will accommodate. The diameter of the blade also affects the maximum thickness of stock the saw will cut.*

Illus. 1-19. *Large or heavy pieces of stock can be supported on this large table extension.*

Most table saws have lugs near the blade's periphery. These lugs limit blade size and eliminate the chance of installing an oversized blade. Some people use an undersized blade on the table saw, but the largest blade that the saw will accommodate actually determines the saw's size.

On saws of marginal power, a smaller-diameter blade may be more effective. Turning a smaller blade leaves more energy for cutting wood.

Coarser blades are also more effective than finer blades. Coarse blades have fewer teeth than fine blades. The coarse teeth remove larger chips with less friction.

Maximum Depth of Cut

The maximum depth of cut determines the thickest piece of stock that can be cut with the table saw in a single cut. All 10-inch table saws do not have the same maximum depth of cut.

Motorized saws will not usually cut as deeply as a motor-driven saw. This is because the motor limits blade height when it hits the underside of the table. When comparing motor-driven or motorized table saws, you will find that the maximum depth of cut varies even among similar types of saw. You may also find that the depth of cut at a 45-degree angle will also vary. If you are thinking about buying a table saw, make sure that its depth of cut is adequate for the work you intend to do.

Table Extension

Table Size

The size of the table on a table saw is also important when you are considering table-saw size. It is much easier to balance and control large sheets of stock on a large surface. Not all 10-inch table saws have the same size table or work surface.

It is possible to build a large wooden table around a bench saw or small table saw. This increases the working area and makes the table saw more versatile. Extensions may also be attached to the fence or the sides or ends of the table saw. This allows greater support and control when long, wide, or thin pieces of stock are being cut. (See Illus. 1-19.) If you plan to move the saw from one job to another, then a small table may be desirable, for portability.

Maximum Ripping Width

The widest piece of stock that can be ripped (cut with the grain) is another size determinant on the table saw. The length of the rails on which the rip fence travels determines the maximum ripping width. (See Illus. 1-20.)

Most 10-inch saws have rails 28-30 inches long. These rails allow a 12-inch rip on the left or right side of the blade. They can also be adjusted for a 24-inch rip on the right or left side of the blade.

Some 10-inch saws allow for a 12-inch rip on the left side and a 24-inch rip on the right side of the blade. This is a desirable set-up. It allows rip cuts to be made up to the center (width) of panel stock on the right side of the blade, and provides for occasional cuts on the left side of the blade.

Other rails are offered for certain table saws. These rails allow for a 50-inch rip on the right side of the blade. (See Illus. 1-21.) They also allow the saw to crosscut to the center (length) of 4-foot × 8-foot panel stock.

Many manufacturers of table saws offer more than one length of rails. Usually the saw is sold with the shortest rails available. This is because the longer rails require a much larger working space. Consult the manufacturer's catalogue to determine what rails are available for your saw.

Illus. 1-20. *The length of the fence rails determines the maximum ripping width. This saw is set up for a 24-inch rip on the right side of the saw. Note that a left rip cannot be made with the fence rails in this position. (Photo courtesy of Delta International Machinery)*

Illus. 1-21. *This Unifence™ rides on 50-inch rails. It may be reversed so that the fence face points in the opposite direction.*

Distance from Table Front to Blade

The distance from the front of the table to the front of the blade (at full height) is also an important measurement. The greater the distance, the

Illus. 1-22. *The distance from the front of the table to the blade is also an important table-saw measurement. The more wood on the table before (and after) cutting, the safer and more accurate the cut. A large table makes cutting safer and requires less energy.*

greater the control over the work. This is important when cutting with or across the grain.

It is much safer to balance a large piece of stock on the table before the cut begins. If the distance from the table front to the blade is minimal, cutting begins almost as soon as the stock touches the table. This could cause binding or a kickback. Greater strength and skill are needed to obtain a good cut when the distance from the table front to the blade is small.

Larger tables usually have a greater distance between the front of the table and the blade. (See Illus. 1-22.) This allows the stock to be lined up with the fence before cutting begins.

Horsepower

Horsepower is an important table-saw-size consideration. Several motors of varying horsepower ratings can be used on the same saw. The motors may all have the same outside dimensions, which makes motor selection even more difficult. The following will help you determine which size motor your saw needs. It will also clarify the terms rated horsepower and peak horsepower.

Rated Horsepower vs. Peak Horsepower Horsepower is a function of torque and rpm (revolutions per minute). The peak or developed horsepower is the horsepower of the motor when it has no load. Rated horsepower is the horsepower under load, and is lower than the peak horsepower. These two horsepower evaluations are different. They cannot be used for comparison purposes.

Generally, motors can be best compared by looking at their amperage ratings. A 10-ampere, 110-volt motor has an actual horsepower of 1. This motor has about the same power as a 5 ampere, 220-volt motor. When possible, select a 220-volt motor or, if the motor will operate at 110 or 220 volts, set it up for 220 volts. It will work more efficiently.

How Much Horsepower is Needed Most table saws come equipped with a motor that ranges from ½ horsepower (rated) to 10 horsepower (rated). This is a considerable difference in horsepower. A ½-horsepower motor would be found on a 7½-inch table saw. This is because the saw turns a smaller blade and is not designed to cut thick stock.

A 16-inch table saw would have a 5- to 7-horsepower (rated) motor on it. A 10-inch table saw can have a 1-, 1½-, 2-, or 3-horsepower motor. The large variety in horsepower is due to the different jobs these saws might perform. If a 10-inch saw is used to cut framing lumber, a 2- or 3-horsepower (rated) motor would be selected. This is because the stock is not as dry or true as furniture lumber. It is twisted or warped, which may put extra strain on a smaller motor. The extra moisture in framing lumber means that more horsepower is needed to throw or eject the heavier sawdust.

Table saws that are purchased for heavy ripping or dadoing operations should have the largest available horsepower motor installed. Ripping requires about five times as much energy as crosscutting. Turning a large dado head and making dado cuts also requires more energy than general sawing.

In most cases, a 10-inch table saw is under-powered if it has a 1-horsepower (rated) or smaller motor. A 1½-horsepower (rated) motor should be the smallest motor installed on a 10-inch table saw used for general-duty sawing.

A 10-inch table saw with an 8-inch-diameter blade mounted on the arbor will have more power. More power is available to cut, since less power is used to turn the smaller blade.

When using a smaller-diameter blade, be sure that its rpm rating is correct for your saw. The blade's peripheral speed will decrease. This means that feed speed (speed at which stock goes through the blade) will also decrease. This could mean increased friction and burning. Smaller-diameter blades should have fewer teeth than the larger-diameter blade that has been removed.

Larger-horsepower motors also have more energy to eject or kick stock back towards you. This is why I have taught many beginning students on a ½-horsepower, 7½-inch table saw. Stock that binds on this saw usually freezes the blade and does not kick back.

Remember, an overpowered saw in the hands of a beginner is similar to a sports car with a beginning driver at the wheel. Select the saw size ac-cording to the work you do. A 10-inch saw may be too large for miniature work and too small for panel work.

Controls and Accessories

Controls

There are three common controls on all tilting-arbor table saws: the power switch, the blade-elevating wheel and the blade-tilting handwheel. (See Illus. 1-1.) On tilting-table saws, there is a table-tilting mechanism and table-raising mechanism instead of a blade-tilting and blade-elevating mechanism. (See Illus. 1-23.) In addition, some table saws are equipped with a brake. The brake stops the blade as soon as the saw is shut off.

Power Switch Table saws have many types of power switches. Some use a conventional light switch, while others are more specialized. Specialized switches are easier to turn off than on.

Illus. 1-23. This table saw has a table-tilting and a table-elevating mechanism. The blade does not tilt or move up and down. (Photo courtesy of Garrett Wade)

Illus. 1-24. *This power switch is attached to the fence rail. It is positioned for easy access. The on portion of the switch is housed. This makes it easy to identify the on (or off) portion by touching it. This is a low-voltage switch.*

Illus. 1-25. *This key is inserted into the switch to activate the switch and saw. When the key is removed, the saw cannot be turned on. This is a desirable feature if there are children in your home. Note the reset button to the right of the switch.*

(See Illus. 1-24.) This makes it more difficult to accidentally start the saw. Usually these switches are color-coded, for increased safety. Green is on and red is off.

The power switch should be positioned so that the operator can turn the saw on and off easily without reaching for it. The operator should be able to shut the saw off quickly in an emergency.

Some power switches require that a key be inserted before the table saw can be used. (See Illus. 1-25.) This type of switch keeps inexperienced operators and curious children from operating the saw. Any table saw (or other power tool) in a home where children are present should either have key-activated switches or tools that are kept behind a locked door, to prevent a mishap.

On high-voltage table-saw motors, a low-voltage switching system is used. A 24-volt circuit goes to the motor. This system activates a solenoid on the motor to the on or off position. The 24-volt circuit minimizes the chance of high-voltage electric shock to the operator. A 24-volt circuit makes the table saw much safer to use.

Motor Reset To prevent overloading and burning out the motor, most saws are equipped with a

thermal switch and a reset button. If the motor overheats, the thermal switch opens. It cannot be reset until the motor cools. The reset button is either located on the motor or on the switch. (See Illus. 1-26.) **Caution:** Be certain that the switch is in the off position and all stock is clear of the blade before pushing the reset button. If the switch is in the on position, the motor may start when it is reset. This caution also applies in the event of a power failure.

Blade-Elevating Handwheel The blade-elevating handwheel controls blade height through a worm-gear and rack-gear mechanism. Most (but not all) handwheels are turned clockwise to elevate the blade. (See Illus. 1-27.)

Most table saws have positive stops at full-blade height. Avoid overcranking the handwheel, as the elevating mechanism can become jammed. This may damage the gear system and require extensive repair.

There is usually a locking device to lock the blade at the desired height. Be sure to loosen this device before changing the height of the blade. Raising or lowering the blade while the locking device is on may damage the saw. Always check the locking device before making any adjustment.

Illus. 1-26. *This reset button is part of a thermal switch. If the saw overheats, the switch opens to protect the motor. Be sure the power is off before pushing the reset button.*

Illus. 1-27. *To raise or lower the blade, first loosen the lock knob in the center of the wheel, and then crank the elevating handwheel. Tighten the lock knob securely when the blade is at the desired height.*

When adjusting blade height, make the final setting as the blade is being raised. This increases the accuracy of the setting. When the blade is raised, there is positive contact between the worm and rack gears. This prevents the gears from slipping because they lash against each other. When the gears lash, the blade cannot lower itself when the saw is turned on.

Blade-Tilting Handwheel The blade-tilting handwheel controls the angle of the blade. Table saws have a protractorlike scale on the front of the saw to help you determine the blade angle. (See Illus. 1-28.) This scale is helpful, but it is not very accurate. It is more accurate to measure the angle between the table and the blade. Use a sliding T-bevel or other device to measure the angle. Make sure that the throat plate is even with the table top when you set this angle.

Illus. 1-28. *The scale is an indicator of blade tilt. It is not as accurate as direct measurement.*

Some other table saws use a different tilt mechanism. (See Illus. 1-11 and 1-12.) Always check for a locking mechanism before tilting the blade.

Brakes Some table saws made today are equipped with brakes that stop the blade instantly after the power is shut off. The brakes can be mechanical or electronic. Mechanical brakes consist of a pad and a drum similar to those on a car's brakes. Some are activated by a solenoid, and others are operated

manually. These brakes must be adjusted periodically, and the pads must be changed when they become worn.

Electronic brakes stop the blade by sending current through the motor. The current counteracts the motion of the motor, causing it to stop. Electronic brakes can easily be installed on most table saws.

Brakes make the table saw safer to operate, and minimize set-up time. The operator does not have to wait for the motor to coast to a stop before changing the set-up. The electronic brake causes no appreciable wear on the electric motor.

Accessories

There are many accessories available for the table saw. Some come with the saw, and others are shop-made or sold as optional equipment. These accessories make the saw safer and easier to use.

Power-Feed Unit A power-feed unit is a motor-operated device that feeds stock into the blade. (See Illus. 1-29.) Used primarily for ripping stock, it reduces operator fatigue and eliminates the monotony that is often the cause of accidents. Operator contact with the blade is also eliminated, since all the operator must do is supply stock to the feed unit.

Power-feed units are set so that they hold stock against the table and fence while they feed the work into the blade. Some units have an adjustable feed speed, which compensates for wood of varying hardness or thickness, or blades of varying diameter or with a different number of teeth. Gear motors are used for positive feed and have less chance of a kickback. Power-feed units work well when you are dadoing or shaping on a table saw. They are usually sold as optional equipment.

Dust Collector A portable or stationary dust-collection system should be used with any table saw. (See Illus. 1-30.) Some table saws have a built-in dust-collection system, while others require the addition of extra parts for dust collection. Collection of dust at the saw makes the work area cleaner and the environment healthier. In some

cases, dust collection improves the quality of the cut. When you are considering a saw, determine if a dust collector can be used easily with it.

Some manufacturers offer dust-collecting accessories. (See Illus. 1-31.) These can be mounted to the underside of most contractor saws.

Fence The fence is an accessory that is standard equipment with all table saws. (See Illus. 1-32.) The fence clamps to one or two table rails (Illus. 1-33) or is bolted to the table. The fence is used to control stock when you are ripping (cutting with the grain) solid stock or when cutting strips from a piece of sheet stock. The distance between the fence and the blade determines the size of the strips being cut.

Some fences may be tilted to accommodate pieces with bevelled (angled) edges. This feature is usually available only on expensive industrial

Illus. 1-29. *This power-feed unit is an accessory for larger table saws. The wheels feed the stock into the blade. There is little chance of kickback, and the power feeder acts as a barrier between the blade and the operator. (Photo courtesy of Delta International Machinery Corporation)*

Illus. 1-65. *This featherboard is held in position by magnetic force. It is removed from the table with a quick twist of the handle.*

Illus. 1-66. *This shop-made featherboard is designed to be clamped to the fence or table. See Chapter 7 for instructions on how to make a featherboard.*

The featherboard is secured to the table, mitre slot, or fence, and is used to hold stock against the fence or table. (See Illus. 1-67.) It acts like a spring. The feathers deflect and force stock against the fence or table. (See Illus. 1-68.) They help minimize kickback hazards.

Anti-Kickback Devices There are anti-kickback devices that can be used on table saws. Shophelper wheels are rubber wheels that are attached to the fence or a wooden auxiliary fence. (See Illus. 1-69 and 1-70.) These wheels are spring-loaded and turn only in one direction—the direction of feed. Special brackets and gibs are used to secure the wheels to the fence. If there is a kickback, the wheels lock and keep the stock from being ejected.

Shophelper wheels can be used to hold stock

Illus. 1-67. *Magnetic force holds this featherboard in position. The plastic "feathers" deflect and hold stock in position.*

Illus. 1-68. *These shop-made featherboards hold the stock against the fence and table. The featherboards are held in position with C-clamps.*

Illus. 1-69. *This auxiliary fence is attached to the fence. It has a metal track mounted on top.*

Illus. 1-70. *Shophelper™ wheels fit into the track. They are mounted on a sliding gib. They turn in only one direction.*

against the table and fence, reduce vibration, and reduce the chance of kickback.

Shophelper wheels can also act as a barrier between the operator and the blade. They can be adjusted for tension and can also be moved in and out and back and forth on the fence. (See Illus. 1-71 and 1-72.) This means that the wheels can be kept close to the blade, regardless of blade diameter or stock width.

The Ripstrate™ is another anti-kickback device that can be used on the table saw. It attaches to the fence. It is spring-loaded and uses wheels equipped with a braking device to stop a kickback. (See Illus. 1-73.)

A similar anti-kickback device is marketed by Leichtung. (See Illus. 1-74.) It has a cog system which keeps the wheel from turning rearwards if a kickback occurs. (See Illus. 1-75.)

Regardless of the work you are doing, use an anti-kickback device. This will make woodworking safer and more enjoyable.

Push Stick The push stick is a shop-made device. (See Illus. 1-76.) It is used to feed stock through the blade of the table saw. The push stick keeps your fingers clear of the blade and allows you to cut thin or narrow pieces safely.

Push sticks can be made in many different sizes and shapes. They are cut for the job at hand. Since

the push stick has many curves, it cannot be easily made on a table saw. Use a sabre saw or band saw to make a push stick.

Note: Many serious accidents can be avoided by simply using one (or two) push sticks. Therefore, before you do any sawing, cut several push

Illus. 1-73. *The Ripstrate™ is an anti-kickback device that attaches to the fence. (Photo courtesy of Fisher Hill Products)*

Illus. 1-71. *The height of the Shophelper wheels is adjusted by turning the continuous height-adjustment screw.*

Illus. 1-74. *The Leichtung anti-kickback system clamps to the fence. It is spring-loaded. (Drawing courtesy of Leichtung Workshops)*

Illus. 1-72. *The gib adjustment screw is tightened to secure the position of the wheel on the fence.*

Illus. 1-75. *The cogs stop the wheels in the event of a kickback, but they can be flipped over for "freewheeling." (Drawing courtesy of Leichtung Workshops)*

Illus. 1-76. *Push sticks make the job safer and give you more control over the work. Always use a push stick, to give you an extra margin of safety. Chapter 7 contains instructions on how to make a push stick.*

Illus. 1-77. *The thrust of this push stick is primarily towards the table. This stick keeps the stock against the table.*

sticks and keep them near the saw. Plywood scraps make good push sticks.

Several push-stick patterns are furnished for your use in Chapter 7. Use these shapes or modify them to suit your needs. Be sure to round all edges and avoid sharp corners on the push sticks you make. Sharp edges and corners can easily split your skin if they are forced into your hand by a kickback.

The design of the push stick affects the type of control or force you have over the workpiece. You will exert downward control on some push sticks, and forward control on others. (See Illus. 1-77 and 1-78.) Both forward and downward control is used on certain push sticks. Select a push stick which gives you the feel and control that makes the job safe.

Shooting Table A shooting table or board is a shop-made or commercial device that takes the place of the mitre gauge for crosscutting work. The shooting board is usually set for a 90-degree-angle cut. Shooting boards can be set at other angles, but they are usually not adjustable at other angles.

The shooting board provides better control over a large workpiece because it is larger than the

Illus. 1-78. *The thrust of this push stick is forward. This push stick works well when you have to feed the stock into the blade more quickly.*

mitre gauge. The stock also rides on a base. It does not touch the table. This eliminates contact between the work and table. There is no chance that the finished work could be damaged.

The shooting board is a challenging table-saw project. The base is made out of sheet stock ⅜–½ inch thick. Sheet stock with a melamine face is the

Illus. 1-79. *A shooting table or board replaces the mitre gauge for crosscutting. This shop-made jig is controlled by the mitre slots. The clear plastic shield and barrier prevent you from coming into contact with the blade. Screw them securely to the shooting board.*

best type to use because it rides smoothly on the table. The guides that fit in the mitre slots should be made from hardwood, plastic, or metal, so they resist wear. They can be screwed to the board or dadoed into it.

The vertical pieces should be true, and about 1½ inches thick. Make the piece wide enough so that the blade does not cut them in half when elevated to full height. Put a clear plastic shield over the saw blade area, and a barrier behind the fence. (See Illus. 1-79.) This will prevent you from coming into contact with the blade. You may wish to put a piece at both ends of the plywood base, for greater rigidity.

Commercial Shooting Boards The Dubby™ jig is a commercial shooting board. It can also be used for mitring. The backstop pivots off a point close to the blade. Because of the great length of the backstop, the mitre angle is very accurate. This jig works very well for cutting hexagons, octagons, and other polygons.

The angle is easy to set precisely. (See Illus. 1-80.) The Dubby jig also has a length stop, to

Illus. 1-80. *Because the pivot point is so far from the protractor scale, it is easy to make very accurate angle adjustments.*

Illus. 1-81. *An adjustable stop is furnished, to set a perfect 90-degree angle.*

Illus. 1-82. *The Angle Pro shooting board also rides in the mitre slot. It features a clamp to hold stock in position while it is being cut. (Photo courtesy of S & K Enterprises, Inc.)*

ensure that all parts are of uniform length. You can make minor adjustments to it, which will square the backstop to the blade. (See Illus. 1-81.)

Another shooting board on the market is the Angle Pro™. (See Illus. 1-82.) It also rides in the mitre slot. It adjusts for various angles, and also provides clamping pressure to hold the stock in position while the cut is being made.

Dead Man The dead man or roller support is a device used to support long or wide pieces of stock being cut on the table saw. There are many different types of dead man. They can be bought on the market or made in the shop.

Commercial supports are usually made of metal. Their height is adjustable, and they have a rolling device to support the stock. (See Illus. 1-83.) The rolling device makes it easy to move the support around.

Shop-made supports may also have a rolling device made of pipe, closet rod, or a rolling pin. They can be adjustable or fixed. Some shop-made dead man devices are very simple. They are basically a portable workbench sawhorse with a table or a roller clamped to it. (See Illus. 1-84.) A sawhorse with a piece of stock clamped to it can also be used. (See Illus. 1-85.) For occasional use, the simple dead man is suitable, but for frequent use a better one should be made or purchased.

Illus. 1-83. *This commercial roller support or dead man can be easily adjusted to various heights. To ensure best results, make sure that the roller is perpendicular to the blade.*

Illus. 1-84. *The table clamped to this portable workbench sawhorse acts as a dead man. Adjust the table surface so that it's slightly lower than the height of the table saw. This allows stock to move smoothly onto its surface.*

Illus. 1-85. *A sawhorse with a piece of stock clamped to it can also be used as a dead man. This system works well in the field when accessories are limited. (Drawing courtesy of Sears, Roebuck and Company)*

Portable Bases Portable bases or stands are a popular table saw accessory. Portable bases fit between the saw and the floor. They are equipped with small wheels which make the saw easy to move. The wheels may be locked to keep the saw from moving once it is in position.

The portable base raises the saw less than one inch. (See Illus. 1-86 and 1-87.) The easy-rolling wheels make it easier to move the saw and reduce the chance that moving the saw will take it out of alignment or adjustment.

Some saws offer wheels as an accessory. They attach to the saw legs and make it easier to move the saw about. (See Illus. 1-88.)

Take-off Table A take-off table is a device that butts or is attached to the out-feed side of the table

Illus. 1-86. *This Delta rolling base or stand is actuated when the pedal is pushed down. The saw can be rolled about the shop on this stand. Lift the pedal to secure its position.*

Illus. 1-87. *This HTC rolling base supports both the saw and the legs on its extension stand. To secure its position, tighten the clamps above the wheels.*

Illus. 1-88. *These wheels are sold as an accessory for the saw. They bolt to the legs. Two legs are removed to make the saw portable. When the wheels are added, the position of the saw is secured.*

saw. The take-off table supports the work as it is fed through the blade. This keeps the weight of the workpiece from lifting it off the blade. Some of these tables fold against the saw when they are not in use. Others remain stationary at the end of the saw.

In some small shops, a workbench or fence extension is used as the take-off table. (See Illus. 1-89.) This means that it must be clear when sawing. This set-up may be more awkward, but for limited spaces it is very efficient.

Accessory Storage

Table-saw accessories must be stored in a convenient and safe location. The mitre gauge should hang on or near the saw when not in use. (See

Illus. 1-89. *This take-off table is attached to the fence. The plywood piece supports the work.*

Illus. 1-90.) This keeps it from being dropped or misplaced.

The fence should also be stored in a convenient area. (See Illus. 1-91.) Many fences are damaged because they are left on the floor when they are not being used. Damage to either the fence or mitre gauge encourages the operator to use the table saw without these accessories. **This is dangerous and unnecessary!**

At least one push stick should hang from the table saw at all times. This eliminates the temptation to work without a push stick. Keep several extra push sticks stored in a handy spot. When a push stick gets cut or damaged, cut it in half and throw it away. This discourages the use of an unsafe push stick.

Extra throat plates, arbor nuts, and arbor washers should be stored near or with the saw blades. (See Illus. 1-92.) Mark the back of the throat plate so that you can match it to the correct blade or accessory.

Illus. 1-90. *Store the mitre gauge in an accessible place when it is not being used. A second mitre gauge is useful for special setups.*

Illus. 1-91. *Keep the fence off the floor when it is not being used. This keeps it from being damaged and ready for use.*

Illus. 1-92. *Table-saw accessories should be stored neatly near the saw. The cardboard discs between the saw blades keep them from touching each other and becoming dull.*

BLADES

The blade on a table saw is an essential link in the sawing process. It is important that the correct blade is used. The chapter supplies the pertinent information needed to select a proper blade. Two areas are explored: the factors that play a part in the blade-selection process, and the specific types of blades available that are used the most frequently.

Blade Selection

There are several factors you must consider when selecting a blade. In addition to tooth style and configuration (see pages 47 and 48), you must have an understanding of the relationship between the saw, its power and tolerances, the wood, and the

Illus. 2-1. *These two carbide-tipped blades resist wear better than tool-steel blades. Note that the carbide tips vary in size.*

Illus. 2-2. *Tool-steel blades are inexpensive and generate less friction. From left to right: rip, crosscut, and combination blades. Rip blades are designed to cut with the grain of the wood. Crosscut blades are designed to cut against the grain. Combination blades are designed to do both.*

Blade Deflection A condition in which the circular-saw blade bounces away from the workpiece.

Carbide-Tipped Blade A blade with teeth made from small pieces of carbide. Carbide-tipped blades are much harder and more brittle than the steel used for conventional blades. They are also more expensive, but require much less maintenance. Carbide-tipped blades come in the following classifications: rip, crosscut, hollow-ground, and plywood.

Coarse Blade A blade with large teeth, designed for heavy, fast, or less delicate work.

Fine Blade A blade with small teeth, designed for more delicate work.

Crosscut Blade A blade that cuts across the grain. Crosscut blades have smaller teeth than rip blades. These teeth come to a point, not an edge.

Footprint (blade) Amount of blade engaged with the workpiece.

Friction The amount of resistance caused by contact between the sides of the blade and the saw kerf.

Hollow-Ground Blade (also called Planer Blade) A blade with no set. The sides of the blade are recessed for clearance in the kerf. Hollow-ground blades should be used to cut mitres and compound mitres, but not used for heavy ripping.

Kerf The cut made by a circular-saw blade. The kerf must be larger than the saw-blade thickness.

Particleboard Sheet material made from wood chips or wood particles.

Resins Material within the wood which can build up on sides of the blade.

Runout The amount that one surface is not true with another surface, or any deviation from a true orbit.

Rip Blade A blade with a straight-cutting edge that is designed to cut with the grain. Rip blades have deep gullets and large hook angles.

Tear-out (grain) When the blade rips or tears out the grain of a workpiece. Tear-out can occur on the back, top, or bottom of a workpiece.

Tooth Set The bend in the blade's teeth that allows the blade to cut a kerf that is larger than the blade's thickness.

Table 2. *A clarification of the terms that are used in this chapter.*

type and diameter of saw blade. Let's explore this relationship.

Friction is the cause of most sawing problems. When you use a fine blade (a blade with many teeth), there are more teeth in the wood during the cut. Since the teeth are smaller, they take a smaller bite. This causes the feed speed to decrease, which means an increase in friction. Increased friction can overwork the motor and cause burning on both edges of the saw kerf. Regardless of how smooth the cut is, burning will ruin its appearance and reduce edge-gluing strength.

All things being equal, a carbide-tipped saw blade will generate more friction than its tool-steel counterpart. (See Illus. 2-1 and 2-2.) This is because the clearance on a tool-steel blade is obtained by bending or offsetting the teeth. (See Illus. 2-3.) This is known as set. The offset teeth touch a small area in the kerf, so there is not much friction. In thick materials, a tool-steel blade might reduce friction enough to improve the cut. When using a tool-steel blade, make sure that you are using the correct blade for the job. (See Table 3.)

Tool-steel blades do not usually produce as high quality a cut as carbide-tipped blades. Tool-steel

Illus. 2-3. *The set in a tool-steel blade provides clearance for the blade to travel through the kerf and reduces friction during the cut. (Drawing courtesy of Foley Belsaw)*

BLADES

A dull blade will cause slow, inefficient cutting and an overload on the saw motor. It is a good practice to keep extra blades on hand so that sharp blades are available while the dull ones are being sharpened. (See "SAWS—SHARPENING" in Yellow Pages.) In fact, many lower-priced blades can be replaced with new ones at very little cost over the sharpening price.

Hardened gum on the blade will slow down the cutting. This gum can best be removed with trichlorethylene, kerosene or turpentine.

The following types of blade can be used with your saw:

COMBINATION BLADE—This is the latest-type fast-cutting blade for general service ripping and crosscutting. Each blade carries the correct number of teeth to cut chips rather than scrape sawdust.

CHISEL-TOOTH COMBINATION—Chisel-tooth blade edge is specially designed for general-purpose ripping and crosscutting. Fast, smooth cuts. Use of maximum speed in most cutting applications.

FRAMING/RIP COMBINATION—A 40-tooth blade for fascia, roofing, siding, sub-flooring, framing, form cutting. Rips, crosscuts, mitres, etc. Gives fast, smooth finishes when cutting with the grain of both soft and hard woods. Popular with users of worm-drive saws.

CROSSCUT BLADE—Designed specifically for fast, smooth crosscutting. Makes a smoother cut than the Combination Blade listed above.

RIP BLADE—Fast for rip cuts. Minimum binding and better chip clearance given by large teeth.

PLYWOOD BLADE—A hollow-ground, hard-chromed surface blade especially designed for exceptionally smooth cuts in plywood.

PLANER BLADE—This blade makes both rip and crosscuts. Ideal for interior woodwork. Hollow ground to produce the finest-possible saw-cut finish.

FLOORING BLADE—This is the correct blade to use on jobs when occasional nails may be encountered. Especially useful in cutting through flooring, sawing reclaimed lumber and opening boxes.

METAL-CUTTING BLADE—Has teeth shaped and set for cutting aluminum, copper, lead, and other soft metals.

FRICTION BLADE—Ideal for cutting corrugated, galvanized sheets and sheet metal up to 16 gauge. Cuts faster, with less dirt, than abrasive disc. Blade is taper-ground for clearance.

COMBINATION

CROSSCUT

RIP

PLYWOOD

PLANER

FLOORING

CARBIDE TIP

METAL

FRICTION

FRAMING BLADE

Table 3. *Use this chart to select the proper tool-steel blade for the job you are doing. (Drawing courtesy of Sears, Roebuck and Company)*

blades do not stay sharp nearly as long as carbide-tipped blades, so they are used as a last resort to reduce friction on a thick cut. Tool-steel blades are not appropriate for materials such as particleboard and fibre-core plywood.

As a guideline, try to keep 3-5 of the blade's teeth in the wood during the cut. This will minimize the amount of friction and maximize speed. Remember, as the stock gets thicker, there are more teeth in the wood. (See Illus. 2-4 and 2-5.) This reduces feed speed. This taxes the saw motor and increases friction. The solution is to replace the blade with a coarser one.

If you tilt the saw blade, friction will also increase. For example, if the blade has five teeth in the wood and you tilt the blade to 45 degrees, there will now be seven teeth in the wood, and the stock will be 1.4 times as thick. This is because the

Illus. 5-19. *Use one piece as a push stick for the piece before it.*

Resawing

Resawing is the process of ripping a thick piece of stock into two thinner pieces. Resawn pieces are often glued together to make wider panels for cabinet sides or doors. The grain of the two thinner pieces is often matched at the glue line to give a book-like effect. This is commonly known as a bookmatch.

Stock that you intend to resaw should be true, Its edges and faces should be parallel. There should be no knots or other defects.

Use a rip or combination blade to resaw stock. The teeth should have a moderate set. (See Illus. 5-20.) This will minimize pitch accumulation, binding, and the chance of kickback.

Note: Tool-steel blades with plenty of set will reduce friction, but produce a rougher cut. Carbide-tipped blades with finely ground teeth will produce smoother cuts, but they will require much more energy to resaw stock. If your saw has a small motor, then a tool-steel blade will be more efficient.

Select a piece of stock that is thick enough to yield pieces of the desired thickness. For example, a ¾-inch-thick piece of stock cannot be re-

sawn into two pieces that are ⅜-inch thick. This is because the saw blade will turn ⅛-inch or more of the thickness into saw kerf. A ¾-inch-thick piece will produce two pieces of ¼-inch-thick stock with no trouble. This allows ¼-inch for a saw kerf and sanding or planing of the sawn surfaces.

Illus. 5-20. *This stock is ready for resawing. Its edges and faces are parallel, and the piece is free of knots or defects. Remember to allow space for the saw kerf. For example, you cannot get two ½-inch-thick pieces from a one-inch-thick piece because the saw kerf takes up a certain amount of space. Select a blade with medium-sized teeth and a moderate set. This will reduce friction.*

Set the distance from the fence to the blade of the desired stock thickness. Allow approximately ¼-inch of extra thickness for sanding or planing the stock. Set the blade height at slightly less than ½ the stock width, or no more than 1 inch. (See Illus. 5-21.)

Position a featherboard to hold stock against the fence during the cut. With the stock's face against the fence and an edge on the table, make a rip cut through the piece. (See Illus. 5-22.) Place the other edge on the table, and make another rip cut. (See Illus. 5-22.) Keep the same face against the fence. On narrow stock, there will be a thin strip separating the two pieces. In most cases, the pieces will split apart easily. (See Illus. 5-23.)

Illus. 5-21. *Set the blade height to slightly less than ½ the stock width, or about one inch. Always choose the lower height.*

Illus. 5-22. *Clamp a featherboard to the table to hold the stock in position. Do not put the featherboard next to the blade. This could cause blade binding, and possible kickback. Make the first rip cut through the edge of your stock. Make the second rip cut from the other edge of the stock.*

Illus. 5-23. *If a small strip remains between the parts, the parts can be split apart easily. When the parts are held together by the thin strip, you are handling only one piece of stock. If the piece is cut completely, you must control two parts.*

They can then be sanded, planed, or glued together. *Note:* Since a guard cannot be used for this operation, control the work with featherboards and push sticks.

On wider stock, the blade will have to be raised another inch, or to slightly less than ½ the stock width. Make a rip cut from the edge. Be sure to keep the same face of the stock against the fence. Separate the pieces when a thin strip remains. (See Illus. 5-24.)

As a general rule, set the blade at 1 inch for each cut, to reduce the stress on the blade and mini-

mize the chance of kickbacks. The stock hardness, blade type and tooth configuration, and the horsepower of the saw may allow a slightly higher (or lower) setting. Experience will tell you the correct setting for your saw.

When resawing some pieces, you may wish to make cuts with both faces of the stock touching the fence. (See Illus. 5-25.) This will make the saw kerf wider, and ensure that the resawn pieces are the same thickness. It will be easier to glue the pieces together to make panels when the resawn pieces are the same thickness. (See Illus. 5-26.)

Illus. 5-24. *On wider parts, the blade will have to be elevated another inch, or to slightly less than the stock width. Separate the pieces when a thin strip remains. The material remaining can be sanded or planed away.*

Illus. 5-25. *In some cases, the piece is cut with both its faces against the fence. This makes the saw kerf wider. This reduces the chance of kickback and ensures that both parts are the same thickness.*

Illus. 5-26. *When the pieces are the same thickness, it is easier to glue up panels.*

Crosscutting

Crosscutting is the act of cutting against the grain of the stock. This is done with an accessory such as the mitre gauge, and also with an accessory such as a shooting table or board, or rolling table. (See Illus. 5-27.) The mitre gauge is usually positioned in the left mitre slot. The operator stands behind the mitre gauge. His right hand controls the mitre gauge and his left hand holds the stock against the head of the mitre gauge. (See Illus. 5-28.)

When you crosscut, you will usually remove the fence from the saw. This is because the fence and the mitre gauge should not be used together. This is a potential cause of a kickback. When crosscutting, stand slightly to the left of the mitre slot, with your feet about shoulder-width apart. (See Illus. 5-29.) Spread your weight evenly on both feet.

Illus. 5-27. *The mitre gauge is used for crosscutting. For most jobs, it is positioned in the left mitre slot.*

Illus. 5-28. *Hold the stock against the head of the mitre gauge with your left hand. Control the mitre gauge with your right hand.*

Illus. 5-29. *Position yourself slightly to the left of the mitre slot, with your feet spread shoulder-width apart.*

Illus. 5-30. *Use a utility knife to cut a piece along its layout line. A utility knife severs the wood fibres and reduces the chance that grain will tear out along the cut.*

When crosscutting an individual piece, mark and cut it along the layout line. A pencil line is the most common mark, but a utility knife is sometimes used. The utility knife cuts the wood fibres and minimizes tear-out along the cut. (See Illus. 5-30.)

To ensure that you make a square cut, make sure that the mitre gauge is perpendicular to the blade, and that the blade is perpendicular to the table. Use a square to check the angle. Raise the blade to its full height and position the mitre gauge across from the blade. Place the head of the square against the blade, and the blade of the square against the mitre gauge. Check the angle, and adjust the mitre gauge, if necessary. Make sure that the set of the blade does not tilt the square; this can lead to an incorrect adjustment. Keep the square off the blade's teeth.

To make a crosscut, place the stock against the mitre gauge and move up to the blade. Your layout line should line up with a tooth that points towards the layout line. (See Illus. 5-31.) *Note:* The saw blade should be on the waste or scrap side of line.

Move back from the blade with the stock held firmly against the mitre gauge, and replace the guard. Turn on the saw and advance the mitre gauge, holding the stock firmly. (See Illus. 5-32.) Feed the stock into the blade at a uniform speed. When the piece is cut, retract the mitre gauge. Keep a firm grip on the stock until it is clear of the blade. (See Illus. 5-33.) Do not remove the cut-off until the blade comes to a complete stop.

Note: When crosscutting, keep the fence well away from the blade. Any cut-off stock trapped between the blade and the fence could kick back. Keep the table clear of scraps as you work; accumulated scrap can also be hazard. Clear the scrap with the saw turned off.

Illus. 5-31. *Line up the layout line with a tooth on the blade. The tooth should point towards the layout line, and the blade should be on the waste or scrap side of the layout line.*

Illus. 5-32. *Advance the mitre gauge slowly. Hold the stock firmly against the head of the mitre gauge.*

Illus. 5-33. *When retracting the stock, hold it firmly until it is clear of the blade. Some guards hold the cut-off in position after the cut is made. Do not remove the cut-off until the blade has come to a complete stop.*

Crosscutting Wide Panels

When crosscutting wide panels, it may be necessary to reverse the mitre gauge in the slot. (See Illus. 5-34.) This is because the tongue on the mitre gauge is too short to reach the slot when the mitre gauge is located behind the stock. If the tongue will not stay engaged in the slot for the entire cut, shut the saw off midway into the cut. After the blade stops, reverse the mitre gauge and proceed. (See Illus. 5-35.)

It is also possible to clamp a straightedge on the panel that can ride along the table edge. (See Illus. 5-36.) The straight edge becomes the control surface for the cut. If you perform this cut, make sure that the edge of the table is parallel to the mitre slot. Measure the distance from both ends of the mitre slot. It should be equal.

Some table saws offer an extension for the mitre slot. This means that you can use the mitre gauge to make a wide crosscut without having to reverse it midway into the cut. (See Illus. 5-37.) For production work, this extension is a useful accessory. It can be conveniently mounted to the saw. This makes it easy to remove and install. Make sure that you have adjusted and positioned the extension correctly for accurate sawing.

Illus. 5-34. *Sometimes you have to reverse the mitre gauge when crosscutting wide panels. This is because the stock is wider than the tongue on the mitre gauge. The mitre gauge has to be reversed in the middle of the cut. This cut should be made with the guard in position.*

Illus. 5-35. *When the stock is balanced on the table, shut off the saw. Allow the blade to come to a complete stop. Then reverse the mitre gauge and proceed with the cut. This cut should be made with the guard in position.*

Illus. 5-36. *A straightedge clamped to the work can be used as a fence on large pieces. The straightedge rides along the end of the table. This cut should be made with the guard in position.*

Illus. 5-37. *If you use a mitre-slot extension, you can make a wider crosscut without having to reverse the mitre gauge. This mitre-slot extension can be easily removed when it is not being used.*

Crosscutting Several Pieces of the Same Length

It is frequently necessary to crosscut several pieces to the same length. To eliminate layout of individual pieces, use a stop rod or a stop block. A **stop block** is a true piece of stock that is clamped to the table, fence, or mitre gauge. It locates one end of the part. This end should already be square. The distance from that end to the blade is the desired-part length.

When clamping the stop block to the fence (Illus. 5-38–5-41) or table, do not clamp it near the blade. Keep the stop block towards the front of the table. This will eliminate pinching and prevent kickbacks.

Note: the stop blocks used should be big enough to ensure that the distance between the blade and fence is greater than the diagonal distance of the parts you are cutting. (See Illus. 5-42.) If it is not, one corner of the part could contact the fence, while the corner diagonally contacts the blade from the first corner. This would result in a kickback.

You can clamp a stop block to a shooting board

Illus. 5-38. *Measure the distance from the blade to the stop block, and then position the fence.*

Illus. 5-39. *Clamp the stop block to the end of the fence closer to you.*

Illus. 5-40. *Butt the squared end of the work against the stop block and make the cut.*

Illus. 5-41. *All parts are cut uniformly with a minimum of layout and measurement.*

Illus. 5-42. *Always use a stop block that allows clearance between the fence and blade for any width you are cutting. The distance between the blade and fence should be greater than the diagonal distance across the widest part.*

or to a piece of stock attached to the mitre gauge. (See Illus. 5-43 and 5-44.) Adjust the clamp so that your vision or movement is not impaired. A clamp of the correct size will minimize this problem.

The *stop rod* is an accessory made for the mitre gauge. It attaches to either side of the mitre gauge. To use a stop rod, adjust it to the correct stock length and lock it in position. Hold the stock against the mitre gauge. One end of the stock should touch the stop rod. (Illus. 5-45.) Cut the other end to the desired length. Make sure that the end that touches the stop rod has been squared before you make the cut. A precision set-up does little good when the stock is not square.

Note: The most common mistake made with the stop rod is to run the stop rod into the saw blade. Double-check the stop rod's position and blade height before you make a cut. Failure to do so could damage the stop rod or the saw blade.

Stop Block

Shooting Board

Illus. 5-43. *You can clamp a stop block to a shooting board to control stock length.*

Illus. 5-44. *A stop block can also be clamped to a piece of stock which has been screwed to the mitre gauge. This extends the control surface and improves cutting accuracy.*

Illus. 5-45. *A stop rod can also be used for crosscutting parts to length. Butt the square end of the stock against the hook on the stop rod, and make the cut.*

When cutting several pieces, work carefully. Do not feed too fast, or grain tear-out will increase. Keep extra pieces well away from the blade, and do not allow scrap to accumulate.

Commercial cutting jigs such as the Dubby jig are available as a crosscutting or mitring accessory for most table saws. (See Illus. 1-80.) This device offers greater control and accuracy than a conventional mitre gauge. It also makes it easy to adjust odd angles because its protractor scale is so much larger.

Clamping Stock for Crosscutting

In some crosscutting operations, it is desirable to clamp stock in position. Clamping stock can increase cutting accuracy and control over the work-

Illus. 5-46. *This mitre gauge is equipped with an adjustable clamping mechanism. Position the clamp pad according to the stock thickness, and secure it in place.*

Illus. 5-47. *In this set-up, a stop and a clamping mechanism are being used for greater control and cutting accuracy. (Photo courtesy of JDS Company)*

piece. Commercial or shop-made clamps can be used. (See Illus. 5-46 and 5-47.)

Most clamps bear down on the tongue of the mitre gauge. This keeps stock from creeping or moving during the cut. If the stock moves while it is being crosscut, clamp it. If the stock still moves, the saw may be out of alignment.

The wider the piece you are crosscutting, the more the stock is likely to move. This is because once the board is engaged with the blade, it tends to follow the blade's path. This will make creep more pronounced in wider stock.

Crosscutting Heavy Pieces

Heavy pieces of stock are more difficult to control. Their weight can lift the mitre gauge out of its slot and reduce your control over the crosscut. A shooting board will provide greater control over a heavy part. If a cleat is clamped to the control face of the shooting board, it will support a heavy piece. (See Illus. 5-48.)

The entire shooting board can be used to guide the piece into the blade. The stock is supported on both sides of the cut, and the plastic shield keeps

Illus. 5-48. *When heavy parts are being crosscut, their weight may actually lift the mitre gauge out of its slot. This means that stock support such as a shooting board is necessary. A cleat is clamped to this shooting board. Position the cleat according to the stock thickness. Slide the stock under the cleat to support it during the crosscut.*

Illus. 5-49. *Align the cutting line with the kerf in the shooting board. Then guide the shooting board through the blade. The plastic shield helps you avoid contact with the blade.*

Illus. 5-50. *The barrier on the back side of the shooting board prevents you from coming into contact with the blade as it exits the shooting board.*

Illus. 5-51. *Use a square to check that there is a 90-degree angle between the edges and ends of the board. Make any needed adjustments to the mitre gauge setting.*

Illus. 7-42. *Since the included angle between the fences is 90 degrees, the frame requires little fitting or adjusting.*

Illus. 7-43. *If one face and one edge of the frame stock are not true, then it will be difficult to cut a square frame.*

5. Use a jig and stop rod to cut accurate mitres. Lines drawn on the stock are not accurate enough.

6. Cut stock oversize; if the mitres need to be trimmed, the glass will still fit.

7. Work from the longest to shortest parts. Longer parts can always be cut shorter if an error is made.

8. Fit the parts together before gluing them.

Test the fit of the glass in the parts. Mark the position of the pieces at the corners. This allows you to put them back together the same way.

9. Sand all the parts well before assembly. It is difficult to sand the moulding on an assembled frame.

10. Use glue sparingly. It is difficult to remove glue from the corners of an assembled frame.

Metric Equivalents

INCHES TO MILLIMETRES AND CENTIMETRES

MM—millimetres CM—centimetres

Inches	MM	CM	Inches	CM	Inches	CM
⅛	3	0.3	9	22.9	30	76.2
¼	6	0.6	10	25.4	31	78.7
⅜	10	1.0	11	27.9	32	81.3
½	13	1.3	12	30.5	33	83.8
⅝	16	1.6	13	33.0	34	86.4
¾	19	1.9	14	35.6	35	88.9
⅞	22	2.2	15	38.1	36	91.4
1	25	2.5	16	40.6	37	94.0
1¼	32	3.2	17	43.2	38	96.5
1½	38	3.8	18	45.7	39	99.1
1¾	44	4.4	19	48.3	40	101.6
2	51	5.1	20	50.8	41	104.1
2½	64	6.4	21	53.3	42	106.7
2	76	7.6	22	55.9	43	109.2
3½	89	8.9	23	58.4	44	111.8
4	102	10.2	24	61.0	45	114.3
4½	114	11.4	25	63.5	46	116.8
5	127	12.7	26	66.0	47	119.4
6	152	15.2	27	68.6	48	121.9
7	178	17.8	28	71.1	49	124.5
8	203	20.3	29	73.7	50	127.0

Index

Basics Series

Band Saw Basics
Router Basics
Scroll Saw Basics
Table Saw Basics

Other Books by Roger W. Cliffe

Portable Circular-Sawing Machine Techniques
Radial Arm Saw Techniques
Shaper Handbook
Table Saw Techniques
Woodworker's Handbook